IMAGES
of Rail

WILMINGTON
AND WESTERN
RAILROAD

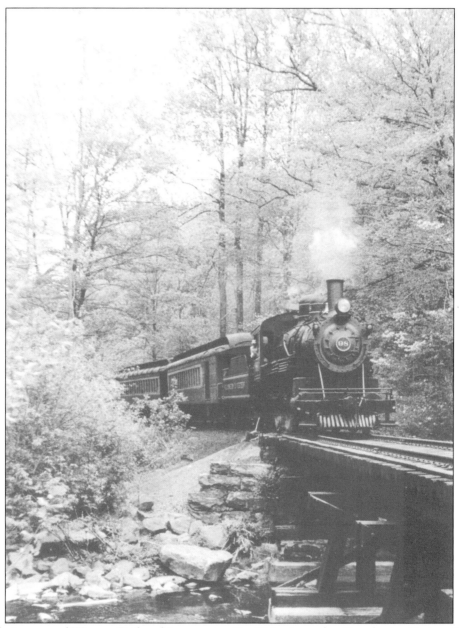

Wilmington and Western Railroad Locomotive No. 98 is pictured at Brandywine Springs Park around 1978 during a regular weekend scenic excursion train ride along the Red Clay Creek. (Courtesy of Historic Red Clay Valley [HRCV], Inc.)

ON THE COVER: In this photograph by Edward J. Feathers, Locomotive No. 98 lays over for a Wild West Robbery train at Yorklyn on June 28, 1992. Actors entertained passengers aboard the train and performed a staged confrontation between marshals and outlaws. The crewmen on the locomotive are fireman John D. Wentzell (left) and engineer Steven L. Jensen (right). (Courtesy of HRCV, Inc.)

IMAGES
of Rail

WILMINGTON
AND WESTERN
RAILROAD

Gisela Vazquez
on behalf of Historic Red Clay Valley, Inc.

ARCADIA
PUBLISHING

Published by Arcadia Publishing
Charleston, South Carolina

Printed in the United States of America

Library of Congress Catalog Card Number: 2007943533

For all general information contact Arcadia Publishing at:
Telephone 843-853-2070
Fax 843-853-0044
E-mail sales@arcadiapublishing.com
For customer service and orders:
Toll-Free 1-888-313-2665

Visit us on the Internet at www.arcadiapublishing.com

This book is dedicated to the Wilmington and Western Railroad volunteers. Their commitment and talents help preserve the railroad's heritage and the rich history of the Red Clay Valley.

CONTENTS

ACKNOWLEDGMENTS

Special thanks are extended to Thomas C. Marshall Jr., David S. Ludlow, Carole R. Wells, Steven L. Jensen, Brian R. Woodcock, B. Michael Ciosek, Edward J. Feathers, Andrew Gwiazda, Edward A. Lipka, the Friends of Brandywine Springs Park, and to my husband, Jose A. Vazquez, for providing an abundant quantity of photographs and materials related to the topic as well as extensive historical information and accounts that complement the content of this book.

I am thankful to Arcadia Publishing for granting the opportunity to produce a book that reflects an important aspect of the rich history of the Red Clay Valley and to my editor, Katie Stephens, for her assistance, especially during the final stages of the project.

This book would not have been possible without the generous assistance of HRCV, Inc., who allowed access to their archives. The publications and reference materials made available were of key importance. The photographs selected represent a small part of the extensive collection portraying the history of the Wilmington and Western Railroad as Delaware's finest historic steam tourist railroad.

I am particularly grateful for the enthusiastic support and continuous encouragement received from family, friends, and especially the staff and volunteers of the Wilmington and Western Railroad.

INTRODUCTION

The history of the Wilmington and Western Railroad as a historic railroad began in 1958 when Thomas C. Marshall Jr. presented for the first time the idea of an educational and historic Red Clay Valley railroad. It was not as easy to bring the project to life as it was to envision the existence of a tourist railroad. It took patience, diplomacy, perseverance, confidence, financial support, and a group of enthusiastic, determined, and dedicated people to create what is today one of Delaware's finest tourist attractions.

The Wilmington and Western Railroad was chartered in 1867 to move goods between the mills along the Red Clay Creek and the port of Wilmington and officially opened for freight and passenger service on October 19, 1872. Three passenger trains and a mixed freight train operated six days a week on nearly 20 miles of track between downtown Wilmington, Delaware, and Landenberg, Pennsylvania. Much of the line ran through the Red Clay Valley, bustling in the late 19th century with farms, small villages, and water-powered mills. Excessive construction debts and poor management caused the line to fall into foreclosure in 1877. The new owners reorganized the line as the Delaware Western Railroad, which became highly profitable moving kaolin clay, vulcanized fiber materials, snuff, iron, and coal to and from the mills.

In the 1880s, the line was purchased by the Baltimore and Philadelphia Railroad (B&P), a subsidiary of the Baltimore and Ohio (B&O) Railroad. Purchase of the line by the B&P provided the B&O with an access route to compete with the Pennsylvania Railroad (PRR) for passengers and freight traveling between Washington, D.C.; Baltimore, Maryland; Philadelphia, Pennsylvania; and New York City. The line became known as the Landenberg Branch and was for a time the B&O's most profitable branch line.

Passenger business flourished in the late 1880s when a resort opened at Brandywine Springs; by 1930, service was discontinued as a consequence of the Great Depression. Shortly thereafter, the Pennsylvania Railroad discontinued its connecting service to Landenberg. With trucks and automobiles gaining in popularity, the Landenberg Branch saw a sharp decrease in freight traffic, and the line was shortened to Southwood, Delaware, in the early 1940s. In the late 1950s, after the demolition of the large Broad Run Trestle and the growth of residential development after World War II, the line was shortened to Hockessin, Delaware.

In the mid-1960s, Historic Red Clay Valley (HRCV), Inc., was formed and incorporated as a nonprofit organization chartered under the laws of Delaware. The organization worked endlessly and with determination to restore and preserve steam- and diesel-powered locomotives, coaches, historic buildings, and sites with the intention to preserve part of the rich history of the Red Clay Valley. From the beginning, it was agreed that the organization should encompass those who had an interest in steam railroads and those that were interested in the history of the Red Clay Valley. Thomas C. Marshall Jr., Alto J. Smith, John Gotwals, Peter Steele, Melvyn E. Small Jr., Weldin Stumpf, and Willard Crossan became charter members; the first board of directors included C. A. Weslager, Luther D. Reed, Leroy J. Scheuerman, and Emile Pragoff Jr. Weekend steam-powered tourist trains began to offer regular train rides three times a day between Greenbank

Station and Mount Cuba. The Wilmington and Western Railroad was officially dedicated a historic steam railroad on June 23, 1966. The objectives, as outlined in its charter, were and still are "to promote interest in and engage in the operation of early transportation (particularly railroads); to preserve and restore historic sites and buildings; to establish and operate museums; and to issue such publications relating to the Red Clay Creek Valley as the members deem fitting and proper; all for the public welfare and for no other purpose."

In the mid-1970s, the line's new owner, the Chessie System, determined that the line had become a financial burden and filed for abandonment of the Landenberg Branch. With the line due to be demolished, fund-raising began. Finally, in August 1982, the remaining 10.2 miles of the Landenberg Branch were purchased by HRCV, Inc., owners and operators of the Wilmington and Western Railroad.

For three days in September 1999, Hurricane Floyd pounded the East Coast, destroying two trestles, damaging six others, and causing numerous washouts along the rail line. Volunteers and contractors repaired the damage between Greenbank and Hockessin, and on November 25, 2000, the first revenue train again made its way westbound to Mount Cuba. Complete restorations were finalized in 18 months, but the railroad would soon discover that another natural disaster was in store.

On September 15, 2003 (just one day short of the fourth anniversary of Hurricane Floyd), the remnants of Tropical Storm Henri stalled over southern Chester County, Pennsylvania, and produced record amounts of rainfall in the Red Clay Creek watershed. The rushing waters tore through the Red Clay Valley, destroying six historic wooden trestles and reducing the railroad's usable track from 10 miles to 2. While rebuilding of the bridges and tracks were underway, the railroad continued to operate over the shortened line.

On June 30, 2007, the Wilmington and Western Railroad's royal blue coaches, behind a gleaming Locomotive No. 98, proudly entered Hockessin for the first time in almost four years. The Wilmington and Western once again overcame the threat of discontinuing passenger service along the Landenberg Branch. Wilmington and Western Railroad's executive director, David S. Ludlow, drove the ceremonial golden spike, and the line was officially reopened.

Much has changed over the years in the life of the Wilmington and Western Railroad, yet much remains the same. Today the Wilmington and Western Railroad continues to offer steam- and diesel-powered tourist train excursions along its scenic right-of-way and provides an educational and entertaining glimpse back in time while preserving part of the rich history of the Red Clay Valley. Just as in its early years, all this would not be possible without the continuous dedication of its members. The board of directors, staff, and volunteers are paramount to its existence. Without their talents and commitment, the Wilmington and Western Railroad could not fulfill its purpose to the public, just as it would not exist without the support of the community, visitors, and guests who come to ride the trains and enjoy the marvelous beauty and rich history of the historic Red Clay Valley.

One

THE EARLY YEARS
1872–1959

After the Civil War, the increase in industrial activities along the Red Clay Creek prompted a group of business owners to construct a railroad between Wilmington, Delaware, and Landenberg, Pennsylvania. In 1867, the Chester County Railroad was incorporated in both states. Due to amendments to its original charter, the name was changed to Wilmington and Western Rail Road Company in 1869. Construction of the new 19-mile-long railroad began on July 8, 1871. Local workers were hired to blast and clear the rock for deep rock cuts at Wooddale, Mount Cuba, and Landenberg. Wooden trestles and bridges were constructed over the Red Clay Creek, Broad Run, and several smaller streams. Fill and other materials were used to level the right-of-way to less than one percent grade except for the ascending grade into the town of Hockessin. On October 19, 1872, construction was completed and passenger and freight service was offered on a regular schedule. The line also operated a telegraph system, and post offices were established at Landenberg, Hockessin, Yorklyn, Wooddale, and Faulkland Stations.

Defaults on the construction loans forced the foreclosure of the line in 1877. The company reorganized as the Delaware and Western Railroad Company and soon became highly profitable. In 1883, the B&O Railroad formed the B&P Railroad to connect the cities of Baltimore and Philadelphia and acquired the Delaware and Western Railroad Company. By 1886, main track lines connected both cities, and the B&P turned all operations over to the B&O. The former Delaware and Western Railroad section of tracks between Landenberg, Pennsylvania, and the B&O main line became the Landenberg Branch of the Baltimore and Ohio Railroad.

The Landenberg Branch connected with the Pennsylvania Railroad at Landenberg and was the most profitable branch of the B&O for many years. By the 1920s, earnings began a steady decline, and passenger service dwindled. In 1942, the section of track between Southwood and Landenberg was completely abandoned. By 1957, the branch was shorted, for the last time, to Hockessin, Delaware. Freight service was limited to only a few industries.

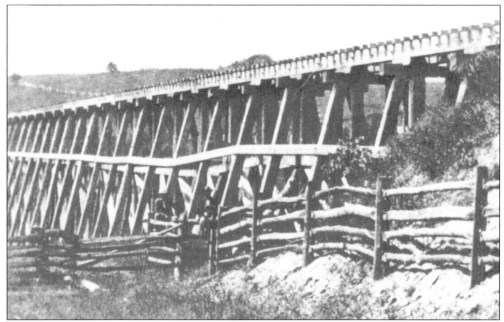

This photograph of the Great Trestle over Broad Run Creek, located between Southwood, Delaware, and Landenberg, Pennsylvania, was taken around 1875. The trestle was 885 feet long and 60 feet high above the creek. Train service to Landenberg was suspended in the early 1940s, and the trestle was dismantled in 1942–1943 after arson fire caused severe damage. (Courtesy of Thomas C. Marshall Jr.)

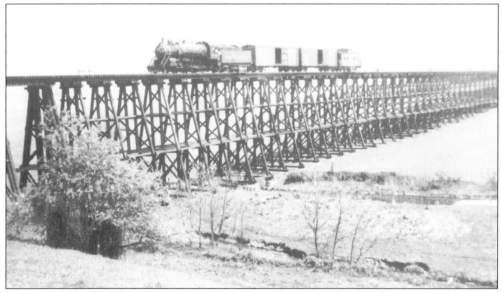

The Broad Run Trestle carried the Wilmington and Western Railroad—and later the B&O Railroad—over marshy meadows just west of the Delaware-Pennsylvania state line. In this photograph dated April 25, 1941, B&O Locomotive No. 2037 traverses Broad Run Trestle hauling freight. No. 2037 was built by the Baldwin Locomotive Works in 1901 as Vauclain compound class B-18e. The locomotive was converted to a class B-19a in 1904 and was sold for scrap in 1954. (Courtesy of HRCV, Inc.)

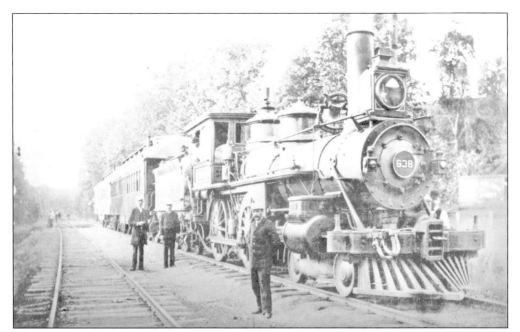

The eastbound B&O morning train awaits departure from Landenberg, Pennsylvania, to Wilmington, Delaware, around 1895. The train stands on predecessor Wilmington and Western Railroad tracks. The adjacent tracks are the Avondale-Newark tracks of the Pennsylvania Railroad (PRR), formerly owned by the Pomeroy-Newark Railroad. (Courtesy of Thomas C. Marshall Jr.)

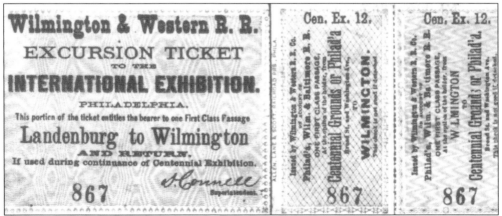

This first-class passage excursion ticket was issued by the original Wilmington and Western Railroad Company in 1876. The International Exhibition of Arts, Manufactures, and Products of the Soil and Mine opened on May 10, 1876, in Philadelphia. It was the first World's Fair hosted by the United States in commemoration of 100 years of American cultural and industrial progress. The exhibition attracted nearly nine million visitors at a time when the nation's population was 46 million. (Courtesy of Thomas C. Marshall Jr.)

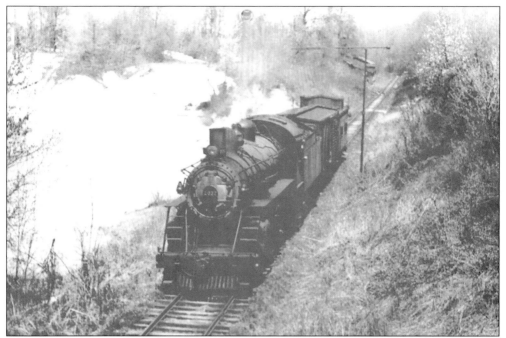

B&O Locomotive No. 2037 climbs the 1.47-percent grade hill between Yorklyn (formerly Auburn) and Hockessin on April 22, 1941. To the left, the open-pit mine is Golding's Quarry. In 1820, deposits of high-grade snow-white clay containing kaolin were discovered at this site. The purity of this clay was highly valued in the manufacturing of fine china. Operations at the quarry ceased in the early 20th century. (Courtesy of HRCV, Inc.)

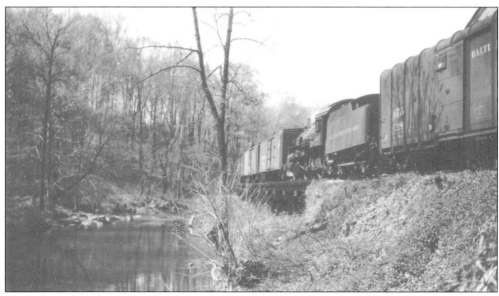

This photograph dates from April 22, 1941, and shows a common sight along the Landenberg Branch, a B&O Railroad freight train crossing over Bridge 12B near Yorklyn. (Courtesy of Thomas C. Marshall Jr.)

The water tank near Yorklyn along Delaware Route 82 was one of three water towers on the original Wilmington and Western Railroad. It was fed by a natural spring and could hold 18,000 gallons of water. The tower was dismantled in 1991. (Courtesy of Thomas C. Marshall Jr.)

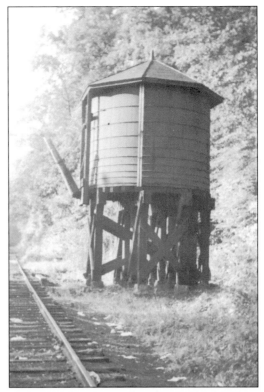

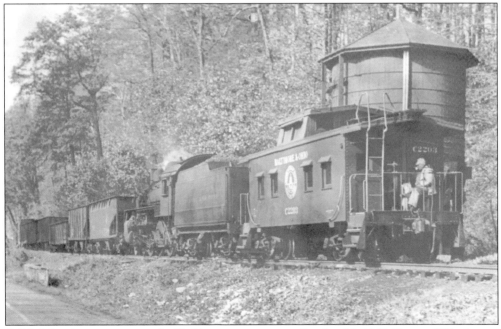

A B&O freight train stops at the Yorklyn water tower on October 25, 1947. Current Wilmington and Western Railroad trains still operate over these tracks west of Sharpless Road during excursions to Ashland and Hockessin. The location of the site is a favorite setting for photographers. (Courtesy of HRCV, Inc.)

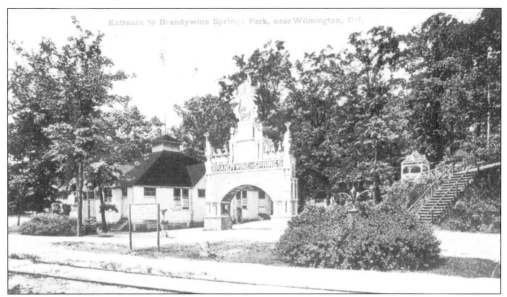

This real-photo postcard depicts the Brandywine Springs Amusement Park prior to 1913. The tracks in front the park's entrance are the People's Railway Trolley Line, which provided service to passengers from Wilmington to Brandywine Springs. The Brandywine Springs Amusement Park dates back to 1890 when Richard W. Crook built a restaurant and toboggan slide. He expanded operations, and by 1907, the attractions included funhouses, a wooden rollercoaster, a roller-skating ring, a theater, a band shell, a miniature steam railroad, and a 6-acre lake. With the arrival of automobiles and a steady decline of interest in amusement parks, Brandywine Springs permanently closed its doors in 1923. (Courtesy of the Friends of Brandywine Springs.)

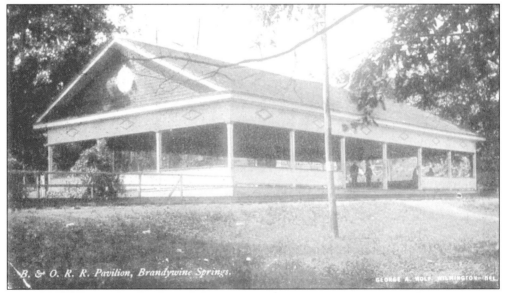

George A. Wolf was a photographer of Wilmington, Delaware, in the early 1900s, and his photographs appeared on many postcards of the time. One of the sites captured by him was the Brandywine Springs Amusement Park. This postcard shows the B&O Railroad Pavilion at the park as it looked at the beginning of the 20th century. The tracks in front of the building are currently used by the Wilmington and Western Railroad. (Courtesy of the Friends of Brandywine Springs.)

Trolley Line Bridge at Brandywine Springs Park crosses over the B&O Railroad tracks around 1902. Trolleys departed from downtown Wilmington to Brandywine Springs Park. (Courtesy of the Friends of Brandywine Springs.)

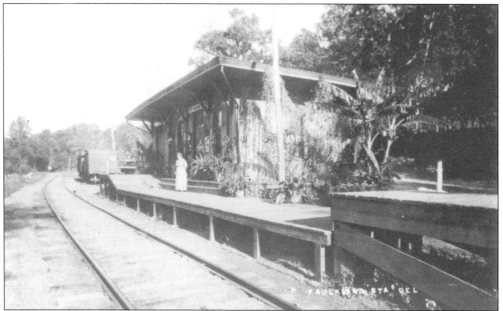

The lady standing on the B&O Railroad's Faulkland Station platform is Mary Agnes Mullins O'Rourke. Her father, John Mullins, came from Ireland in 1863. He later settled in Faulkland, Delaware, and became B&O Railroad's stationmaster. He was appointed postmaster in 1879, and all postal business was transacted at the station. Mary Agnes Mullins O'Rourke succeeded her father as postmaster on June 3, 1887. She lived at Faulkland Station as a young child and continued to do so after she married. Her seven children were born and raised there. The date of this photograph is unknown. (Courtesy of the Friends of Brandywine Springs.)

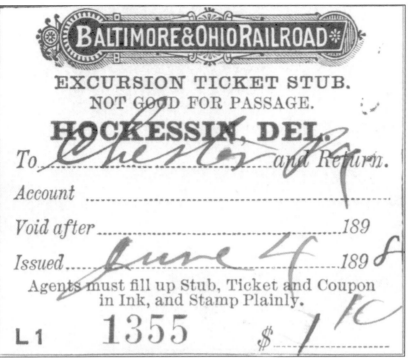

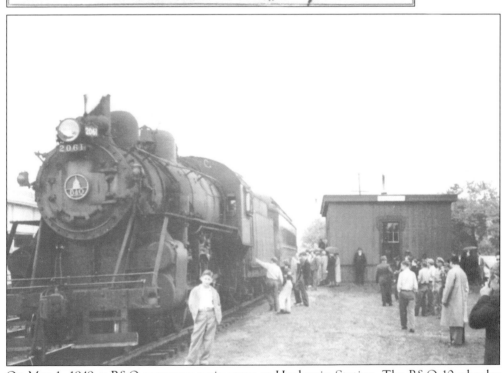

Excursion ticket stub No. 1355 was issued on June 4, 1898, by the B&O Railroad. At this time, the B&O controlled the tracks originally chartered by the Wilmington and Western Railroad Company in 1872. (Courtesy of Thomas C. Marshall Jr.)

On May 1, 1949, a B&O passenger train stops at Hockessin Station. The B&O 10-wheeler Locomotive No. 2061 was built by Baldwin Locomotive Works in 1901 as a Vauclain compound and converted to a class B-18e. It was sold for scrap in 1954. The Hockessin Station built by the B&O Railroad no longer exists. (Courtesy of Thomas C. Marshall Jr.)

Two

LEASING OF THE LINE
1960–1982

Historic Red Clay Valley, Inc., d/b/a Wilmington and Western Railroad leased the Landenberg Branch of the Baltimore and Ohio Railroad from 1965 until 1982. This period marks the beginning of the railroad as a historic steam tourist railroad, which began in 1958 when Thomas C. Marshall Jr. presented for the first time the idea of an educational and historic Red Clay Valley railroad to local historians and preservationists.

In 1965, a lease agreement signed with the B&O Railroad allowed HRCV, Inc., the use of property at Marshallton for an engine house and at Greenbank for a passenger station. It also included the use of five and one-half miles of track between Marshallton and Mount Cuba for passenger excursions on weekends only. Throughout the years, members and volunteers worked side by side to restore and maintain the equipment and structures to provide the means to offer steam-powered excursions.

On Saturday, May 28, 1966, the Wilmington and Western Railroad trains began to offer passenger excursions along the Red Clay Valley. Regular trains on Saturday and Sunday afternoon departed hourly between 1:00 p.m. and 5:00 p.m. to Bayard Taylor picnic grove at Mount Cuba. Special preseason and postseason trips were offered exclusively to schoolchildren. Excursions to Hockessin and Yorklyn were added to the regular train schedule, and several open-house events were hosted at the Marshallton yard, including a full display of the equipment.

Special off-line steam operations on the neighboring Wilmington and Northern Railroad (Reading) and the Octoraro Branch of the Pennsylvania Railroad raised awareness and enthusiasm for the Wilmington and Western Railroad. Trips were scheduled to Northbrook, Modena, Lenape, Kennett Square, and Oxford, Pennsylvania.

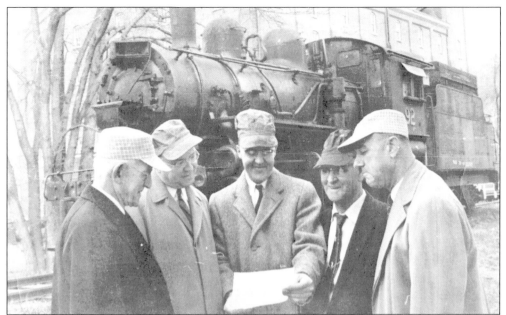

In 1959, Thomas C. Marshall Jr. presented his idea of an educational and historic Red Clay Valley railroad. Approval for the project was granted by the board of managers of recreation, promotion, and service. HRCV, Inc., was established as a nonprofit corporation to operate the new railroad. Canadian National Locomotive No. 92 was purchased by T. Clarence Marshall and moved to Yorklyn, Delaware. From left to right, T. Clarence Marshall, Leroy Roy J. Scheuerman, Thomas C. Marshall Jr., William Greenwell, and George T. Sargisson examine the bill of sale for Locomotive No. 92 the day it arrived at Yorklyn, Delaware. (Courtesy of HRCV, Inc.)

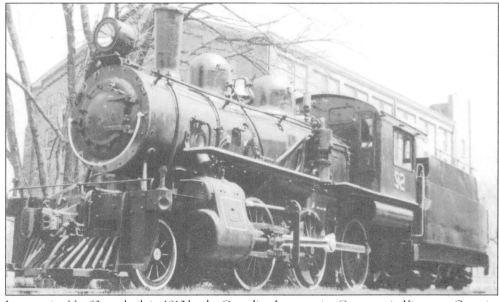

Locomotive No. 92 was built in 1910 by the Canadian Locomotive Company in Kingston, Ontario. Originally a Grand Trunk Railroad class E-8 and numbered 1017, it was rebuilt with superheaters and piston valves in 1913 and reclassified as an E-12. It became Canadian National class E-10a, No. 919, in 1923. The locomotive was renumbered No. 92 in 1951. (Courtesy of HRCV, Inc.)

T. Clarence Marshall owned a 1.5-foot miniature steam railroad, model locomotives, and the Marshall Museum of Antique Automobiles, which included the nation's largest collection of Stanley steam cars, at his home in Yorklyn, Delaware. In 1961, he opened his home to the public as Auburn Valley, a division of HRCV, Inc. Revenues from the weekend events were directed to fund the Wilmington and Western Railroad project. (Courtesy of HRCV, Inc.)

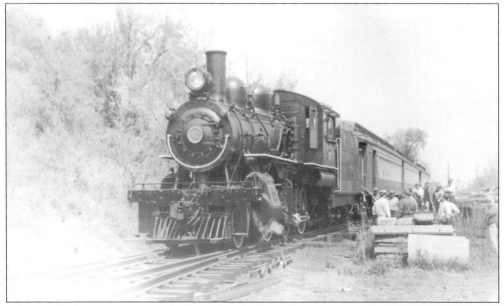

Taken in the late 1960s at Marshallton, this photograph depicts an excursion train being pulled by Locomotive No. 92. This was a common sight during the early years of operations. (Courtesy of HRCV, Inc.)

Thanks to the generosity of a few members of HRCV, Inc., and proceeds from Auburn Valley operations, four open platform coaches were purchased in 1961 from the Erie-Lackawanna Railroad. The coaches were stored at Yorklyn until 1963, when they were moved to East Seventh Street in downtown Wilmington, Delaware. The four steel cars are 70 feet long and weigh 54 tons each. Three of the cars, nos. 571, 581, and 603, have seating capacity for 72 passengers. The forth car, a combine or combination car with a baggage compartment and a passenger section, seats 56 passengers. These coaches were built between 1914 and 1915. The photograph above depicts combine cars similar to coach no. 410; the photograph below shows coach no. 603. (Courtesy of Thomas C. Marshall Jr.)

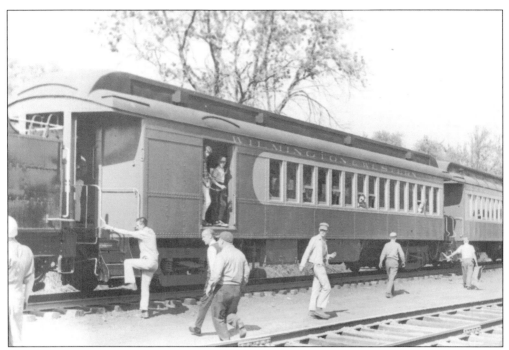

Combine No. 410 waits at Marshallton around 1968 in preparation for a weekend excursion trip. The coaches were restored and painted with the state of Delaware colors: yellow and blue. (Courtesy of HRCV, Inc.)

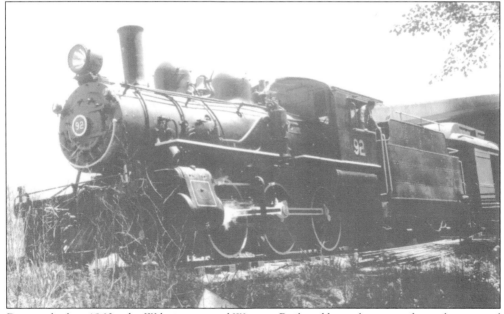

During the late 1960s, the Wilmington and Western Railroad hosted a series of open houses and weekend train excursions three times a day in order to promote and encourage support from the community members. All the work performed was based exclusively on volunteers who restored, maintained, built, and operated the equipment. This photograph, dating from the 1960s, shows Locomotive No. 92 outside the engine house at Marshallton. (Courtesy of HRCV, Inc.)

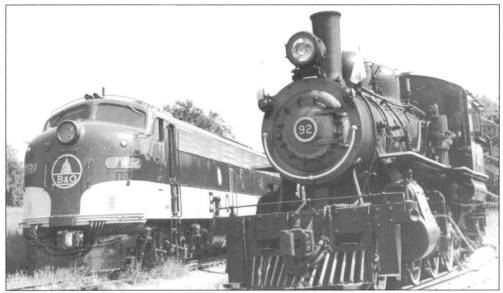

The Wilmington and Western Railroad provided trips for groups that chartered trains for private events. In 1968, guests departed the B&O Railroad Mount Claire Station in Baltimore, Maryland, and arrived at Marshallton, Delaware, on a train pulled by B&O Locomotive No. 1452, class E-8A, built in 1953. The guest locomotive and Wilmington and Western Railroad Locomotive No. 92 stand side by side at Marshallton before Locomotive No. 92 departed with the visitors. (Courtesy of HRCV, Inc.)

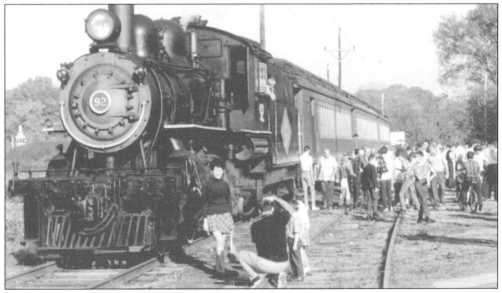

On Saturday, May 28, 1966, the Wilmington and Western Railroad trains began to offer passenger service along the Red Clay Valley as an educational and historical steam tourist railroad. It took seven years of dedication and perseverance from the members of HRCV, Inc. to make this dream come true. Eighty-nine years passed before the Wilmington and Western Railroad trains operated again on the tracks of the Landenberg Branch. This photograph was taken in 1966 at Hockessin. The first runs into the town were well received by the public. Today Hockessin excursions continue to be popular with the riding public. (Courtesy of HRCV, Inc.)

On July 23, 1966, the Wilmington and Western Railroad was officially dedicated. Locomotives Nos. 92 and 98 were brought together at Greenbank Station, facing each other. Between the two locomotives, Thomas C. Marshall Jr. drove the golden spike. The spike was then subsequently driven by Gov. Charles R. Terry Jr., former Delaware governor Elbert N. Carvel, B&O/Chesapeake and Ohio director of passenger service Paul H. Reistrup, and division superintendent of the B&O R. H. Minser. (Courtesy of Thomas C. Marshall Jr.)

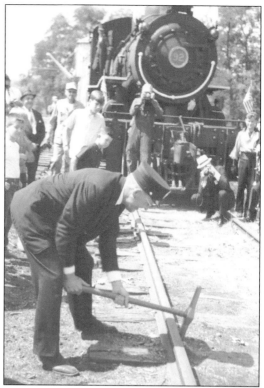

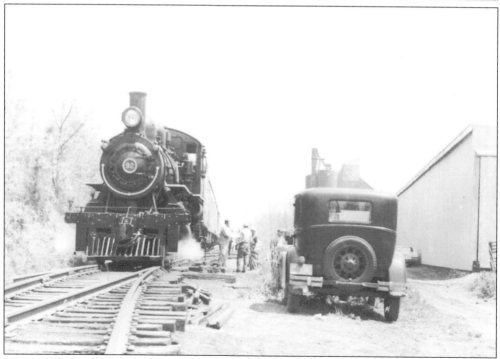

This c. 1969 photograph depicts Locomotive No. 92 at Marshallton before departing to Greenbank Station. (Courtesy of HRCV, Inc.)

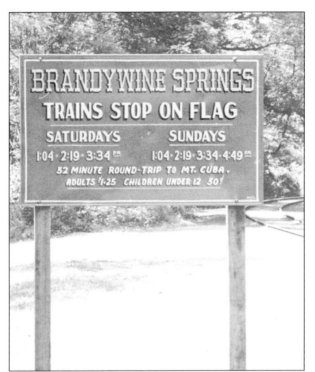

The Wilmington and Western Railroad had a flag stop at Brandywine Springs. Lack of enthusiasm on the part of park officials and the continual destruction of each sign erected soon terminated the option for passengers to stop a train at Brandywine Springs. (Courtesy of Thomas C. Marshall Jr.)

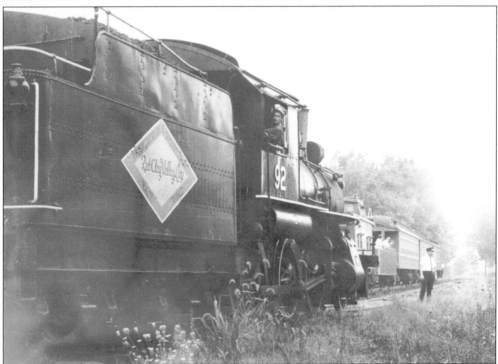

This image was captured at Yorklyn during a run-around move performed to position the locomotive at the opposite end of the consist. The first logo used by the Wilmington and Western Railroad is painted on the locomotive's tender. (Courtesy of HRCV, Inc.)

24

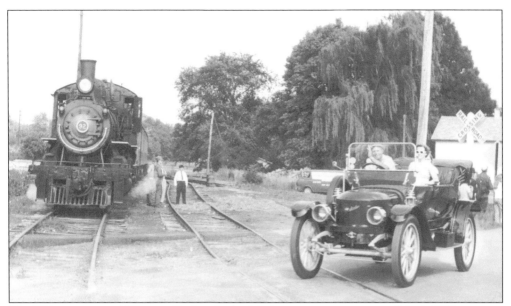

The Wilmington and Western Railroad scheduled an excursion train on July 4, 1972, to carry passengers from Greenbank to Hockessin to partake in the Independence Day parade celebrations. (Courtesy of HRCV, Inc.)

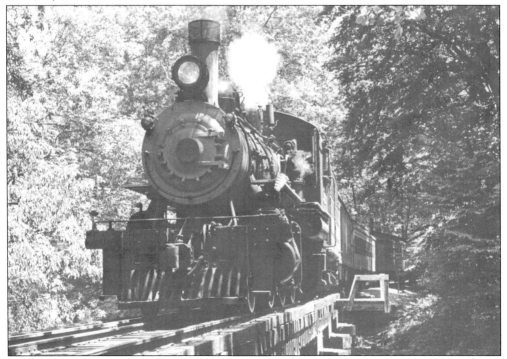

This photograph from the mid- to late 1960s depicts Locomotive No. 92 approaching Bridge 10A over the Red Clay Creek just before the Bayard Taylor picnic grove at Mount Cuba. The grove was named after the famous 19th-century author Bayard Taylor, who served as an ambassador to Germany until his death in 1878. Note the small platform on the right-hand side of the bridge. These platforms are no longer in use along the Landenberg Branch. (Courtesy of HRCV, Inc.)

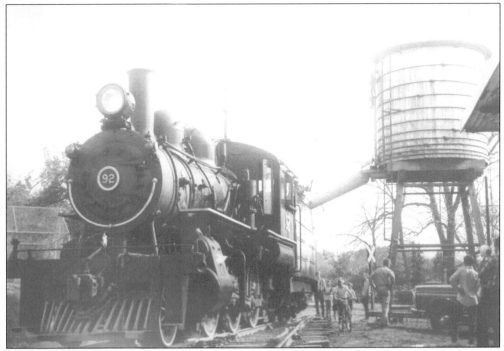

This photograph was taken in 1972 while the engine crew of Locomotive No. 92 takes on water from the tank located at Greenbank Station. At the time, adult tickets were $1.25 and children could ride for 50¢. Regular trains departed from Greenbank Station to the Bayard Taylor picnic grove at Mount Cuba hourly between 1:00 p.m. and 5:00 p.m. Each trip lasted 50 minutes, which included a five-minute stop over at the picnic area. (Courtesy of Brian R. Woodcock.)

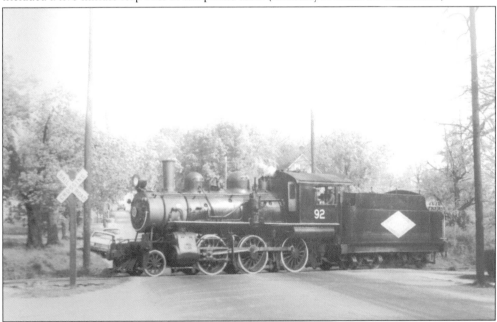

In 1972, Wilmington and Western Railroad Locomotive No. 92 crosses over Delaware Route 41 as it approaches Greenbank Station. The photographer faces south. (Courtesy of HRCV, Inc.)

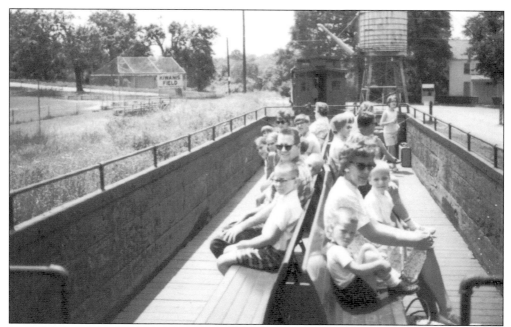

In the early 1900s and up until just before World War II, a few private car lines and railroads owned special suited railcars to transfer chickens and other types of domestic fowl. These cars were referred to as chicken cars. As time passed, the use of these specialized cars diminished; some became surplus, and others were modified to suit the railroad's changing needs. This photograph dates from around 1967 and depicts one of these cars owned by the Wilmington and Western Railroad that was converted to open-car passenger seating. (Courtesy of HRCV, Inc.)

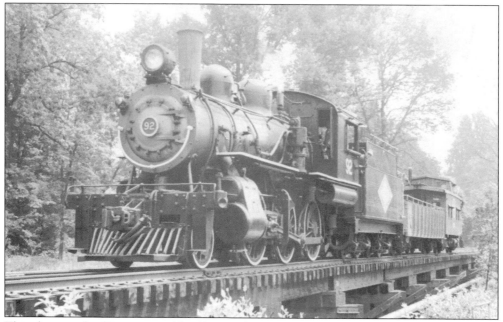

This photograph of Locomotive No. 92 was taken in 1972 as it crosses over Bridge 7A, formerly Hercules Trestle. The consist that day was one modified chicken car and a caboose. (Courtesy of HRCV, Inc.)

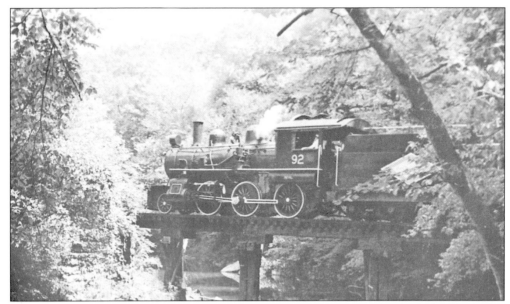

This photograph taken in 1972 shows Locomotive No. 92 as it leaves the Wooddale Rock Cut and crosses Bridge 8B over the Red Clay Creek. At the time of this photograph, the creek was 13 miles long from its headwaters in Marlboro Township, Pennsylvania, to its confluence with the White Clay Creek in Stanton, Delaware. The native name for this creek was *Hwiskakimensi Sippus*, or "young tree stream," from which the present-day word Kiamensi is derived. (Courtesy of Brian R. Woodcock.)

The Ashland Covered Bridge is located on Brackenville Road near the Delaware Nature Society and the Wilmington and Western Railroad. This bridge is of the town-truss type originally built in 1870. It is one of two remaining covered bridges in northern New Castle County. As of this publication, a third covered bridge at Wooddale, destroyed in 2003, was undergoing reconstruction by the Delaware Department of Transportation. (Courtesy of HRCV, Inc.)

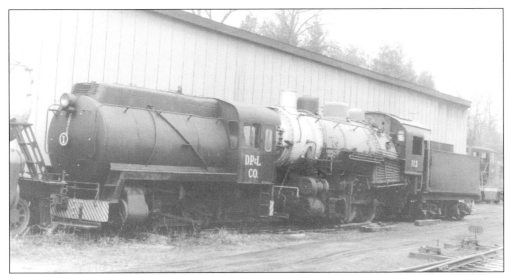

The 50-ton H. K. Porter 0-4-0 industrial Delaware Power and Light (DP&L) Company Locomotive No. 1 was donated to HRCV, Inc., in 1981. Only 14 of the class were ever built. Because of its rarity, HRCV, Inc., welcomed this engine with the intention of preserving it. This "fireless" engine has no firebox. The tank is charged with water and steam from an external source. These locomotives could operate for four to six hours before needing to be recharged. H. K. Porter fireless locomotives are historically significant because they were the last used by private industries throughout America. (Courtesy of HRCV, Inc.)

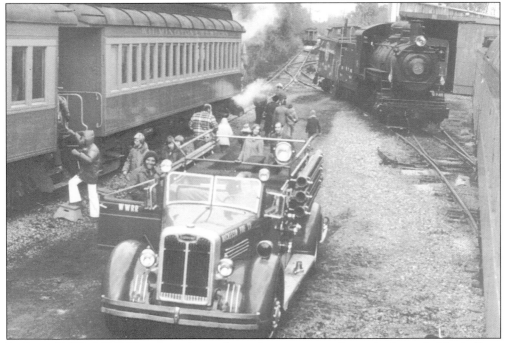

In the mid-1970s, HRCV, Inc., hosted several open-house events at the engine house in Marshallton. These events showcased locomotives, rolling stock, and maintenance-of-way equipment. Shown here is Fire Engine No. 191, previously owned by the Hockessin Fire Company. (Courtesy of HRCV, Inc.)

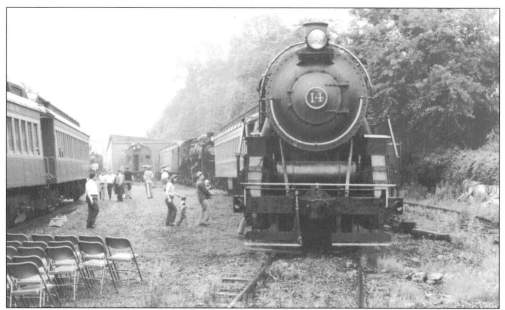

Among the collection on display during the open-house weekends was Locomotive No. 14, built in 1918 by ALCO in Schenectady, New York, with plate No. 59309. Originally built as Kelly's Creek and Northwestern No. 1, it later operated as No. 14 on the Buffalo Creek and Gauley from 1954 until 1964. It was purchased by Quakertown and Eastern but never operated on that line. It was donated to HRCV, Inc., in 1980. This locomotive is no longer owned by HRCV, Inc. (Courtesy of HRCV, Inc.)

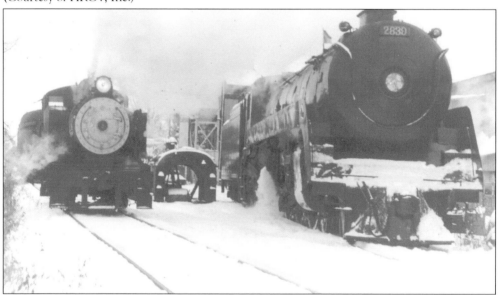

The Royal Hudson No. 2839 on the right was built by Montreal Locomotive Works in September 1937. It is an H1c class locomotive with construction No. 68952. In March 1959, the locomotive was retired to standby service. It was purchased by the Royal Hudson Company in 1970, and two years later, it was purchased and restored by the Atlantic Central Steam Company in Norristown, Pennsylvania. It was moved to Marshallton, Delaware, in 1980 and leased for a short time by HRCV, Inc. (Courtesy of HRCV, Inc.)

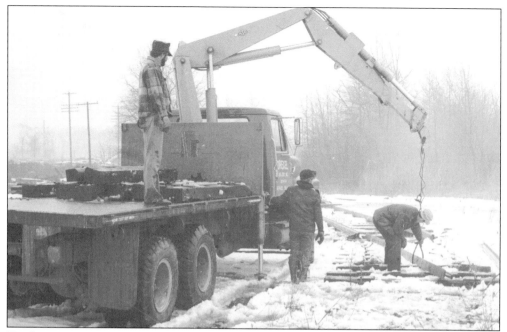

Track maintenance is one of the most important activities performed on any railroad. Here a group of unidentified track workers prepare a new section of track. Despite adverse weather conditions, Wilmington and Western Railroad volunteers persevered with their commitment. (Courtesy of HRCV, Inc.)

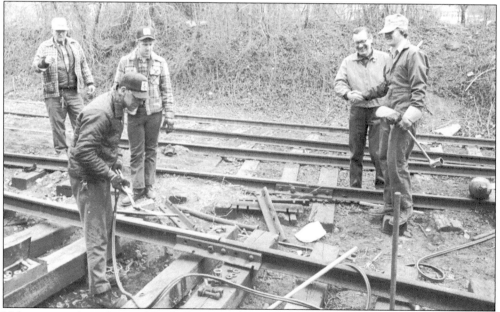

Volunteer track workers at Marshallton install switch components to facilitate switching from the yard tracks to the Wilmington and Western main line. The work consisted of the installation of one switch and a short section of track. In the front is John Jeppi, holding a torch; behind him (from left to right) are Peter Steele, Melvyn E. Small Jr., unidentified, and Terry Burkhart. (Courtesy of HRCV, Inc.)

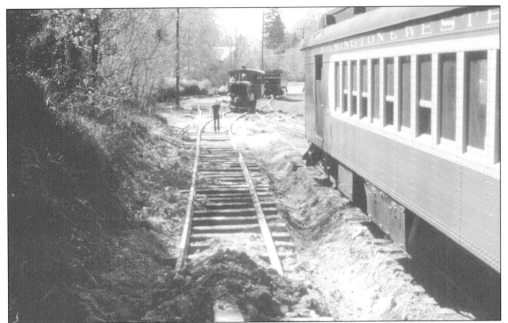

Significant improvements were made at the Wilmington and Western Railroad yard at Marshallton during 1977. This photograph was taken while construction of the No. 1 track was underway. The tracks behind the unidentified person are a section of spur track. Over the years, more improvements and changes took place, including the relocation of the switch connecting these two tracks. (Courtesy of Steven L. Jensen.)

This small locomotive is a 0-4-0 switcher built by the Plymouth Locomotive Works in 1942. Plymouth was a division of the Fate-Root-Heath Company. The locomotive was purchased by the American Car and Foundry and never numbered. HRCV, Inc., purchased the switcher engine from the Wilmington Industrial Park in 1966. It was repainted and given No. 1. (Courtesy of Steven L. Jensen.)

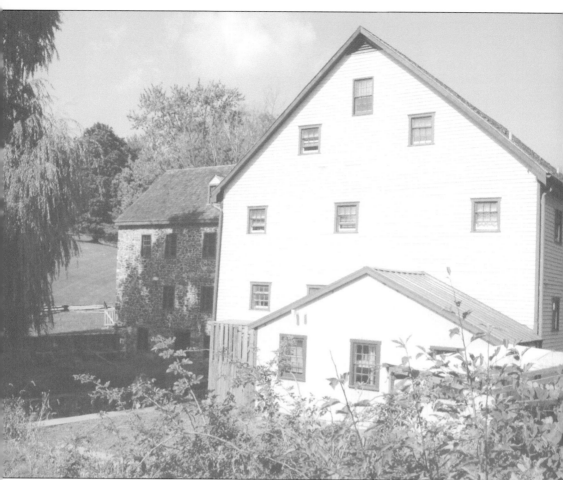

The first mill at Greenbank was called Swede's Mill, dating from 1677. The present gristmill was built in the 1760s as a merchant mill to export flour. In 1790, then-owner Robert Philips contracted with friend and neighbor Oliver Evans (1755–1819) to have Evans's milling system installed. In 1810, a stone addition, the Madison Factory, was added to the building to expand operations. In 1925, J. Roy Magargal (1893–1972) began to work at the gristmill. He owned and operated the mill and a wholesale/retail feed business until 1964 when HRCV, Inc., acquired the historic Greenbank Mill to preserve it as an example of the many water-powered mills along the Red Clay Creek. In 1969, an arson fire destroyed the Madison Factory and 30 to 50 percent of the remaining structure. From 1970 until 1975, an extensive restoration project was undertaken by HRCV, Inc. From 1978 until 1988, the Greenbank Mill was administered by New Castle County, and in 1988, newly formed Greenbank Mill Associates, Inc., took complete control of the operations of the Greenbank Mill. (Courtesy of Gisela Vazquez.)

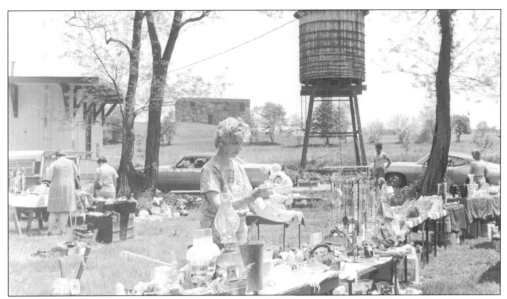

Every weekend during the early 1970s, a flea market was set up at Greenbank Station. The service was open to anyone who would rent a table for $5 a day. If more than 10 dealers participated, a drawing was held at the time when the fees were collected, and one dealer received a free ride. For profits over $50, a small percentage was allocated for the benefit of the Wilmington and Western Railroad. The flea market proved to be an excellent fund-raising event during the years it was operated. (Courtesy of HRCV, Inc.)

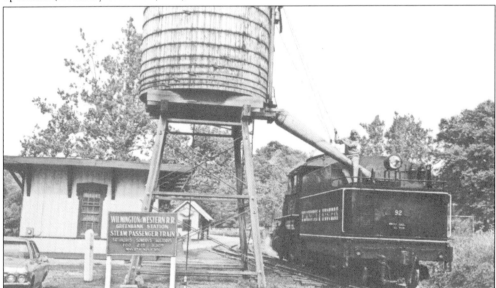

This photograph of Greenbank Station is from a postcard dated to the early 1970s. Several postcards were produced depicting the equipment and structures at the Wilmington and Western Railroad. The lack of passengers in the image reveals the purposed of the trip to the station; this was the only location close to the engine house that could supply a significant volume of water for the Wilmington and Western steam engines. The building on the left is the former B&O Yorklyn Station, and the small building behind the water tower is the former PRR Kennedyville Station from Kennedyville, Maryland. (Courtesy of HRCV, Inc.)

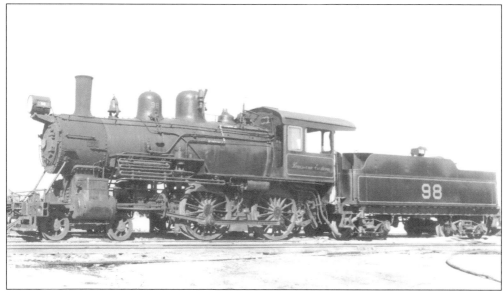

In December 1952, Locomotive No. 98 is photographed in Shiloh, Louisiana, where it operated on the Louisiana Eastern Railroad. (Courtesy of Edward J. Feathers.)

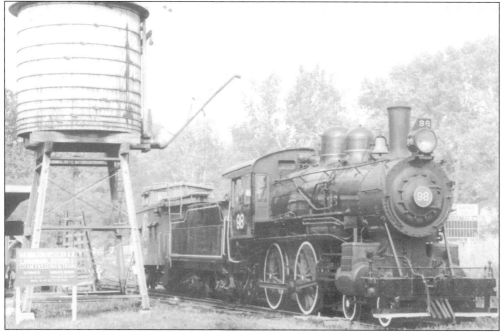

Locomotive No. 98, a 4-4-0 American type, was built in 1909 for the Mississippi Central Railroad by ALCO in Schenectady, New York. It was sold in 1947 to the Louisiana Eastern Railroad. In 1960, T. Clarence Marshall and Thomas C. Marshall Jr. purchased the locomotive from Paulsen Spence, operator of the Louisiana Eastern Railroad. No. 98 weighs 60 tons without the tender and is typical of the passenger engines at the turn of the 19th century. The locomotive was towed on its wheels for 1,500 miles from Amite, Louisiana, to Strasburg, Pennsylvania, before being moved to Wilmington, Delaware. This photograph from the early 1970s shows Locomotive No. 98 facing eastbound at Greenbank Station. (Courtesy Thomas C. Marshall, Jr.)

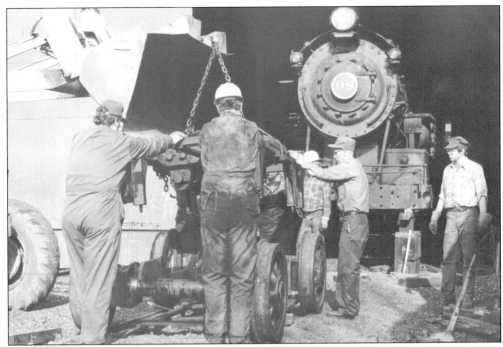

Volunteers and hostlers (from left to right) Robert Hamilton, William Brueckmann, Thomas Coons, Earl Paine, and William Fessenden move the pony truck of Locomotive No. 98 back into position underneath the engine at Marshallton. (Courtesy of HRCV, Inc.)

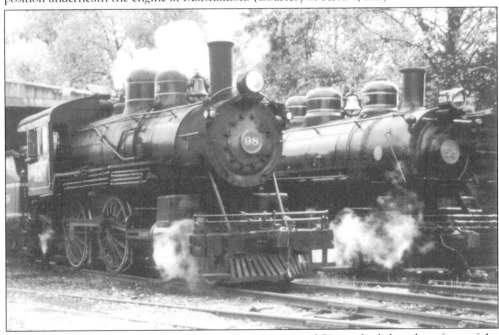

Wilmington and Western Railroad Locomotives Nos. 98 and 58 stand side by side in front of the engine house at Marshallton. No. 98 was used to transport passengers from Greenbank Station to Marshallton Yard. No. 58 was in need of repairs and was placed on display for the open-house event. Note the visor on Locomotive No. 58's headlight. (Courtesy of Steven L. Jensen.)

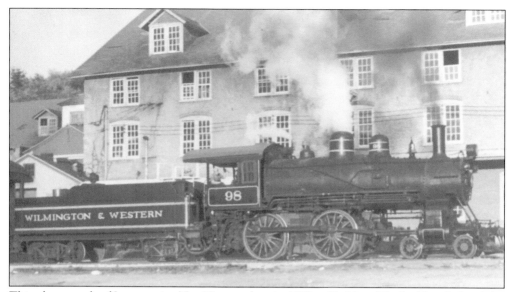

This photograph of Locomotive No. 98 was taken in 1978 at Yorklyn. The building behind the locomotive is part of the National Vulcanized Fiber Company complex. In 1875, the Vulcanized Fiber Company was incorporated in Wilmington under the laws of the State of Delaware as the first vulcanized fiber plant in the United States. In 1922, the National Fiber and Insulation Company at Yorklyn merged with the American Vulcanized Fiber Company of Newark and formed the National Vulcanized Fiber Company. This plant produced, among other products, excellent electrical insulators and circuit boards for a growing industrial demand. (Courtesy of Steven L. Jensen.)

In December 1977, Thomas C. Marshall Jr. donated Locomotive No. 98 to HRCV, Inc. Marshall is a charter member of HRCV, Inc., served as president until 1966, and continues to sit on the board of directors of HRCV, Inc. (Courtesy of HRCV, Inc.)

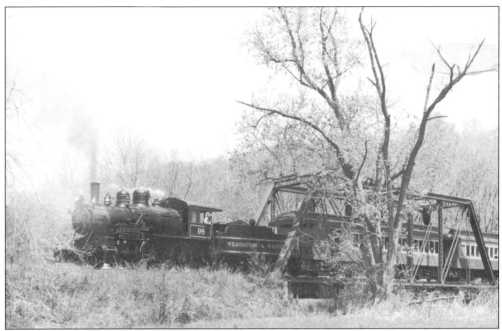

Wilmington and Western Railroad Locomotive No. 98 crosses over the iron truss bridge at Ashland during a spring trip to Hockessin. This is a favorite sight for photographers throughout the year but especially so in the autumn when the foliage displays an array of distinct colors. (Courtesy of HRCV, Inc.)

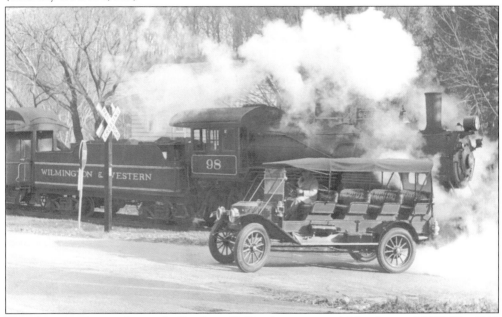

This photograph was taken at the Brackenville Road crossing in Ashland around 1977. The 1912 Stanley Steamer Mountain Wagon owned by Thomas C. Marshall Jr. shuttled passengers from the train to the Delaware Nature Society and back during the Santa Claus Special excursions. Children visited Santa Claus at the nature center and enjoyed hot chocolate before returning to the train. (Courtesy of HRCV, Inc.)

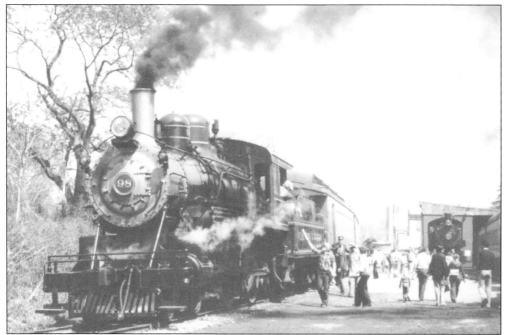

On April 30, and May 1, 1977, tours through the Wilmington and Western Railroad engine house were offered to visiting riders. Steam trains departed from Greenbank Station every half hour, and fares were 50¢ for adults and 25¢ for children. The equipment was lined outside for the benefit of photographers, and guides explained the various functions of the equipment. (Courtesy of Brian R. Woodcock.)

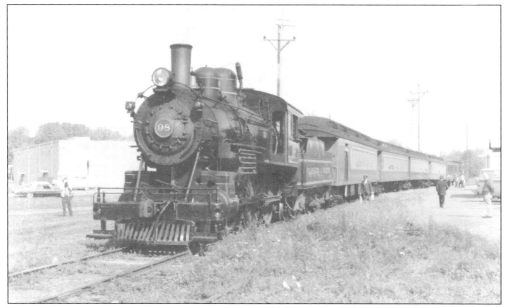

The Wilmington and Western Railroad crew prepares to cut off Locomotive No. 98 from the consist for a run-around move in downtown Hockessin. One crewmember approaches the front of combine coach No. 410 carrying two marker lanterns commonly used to mark the end of trains. (Courtesy of HRCV, Inc.)

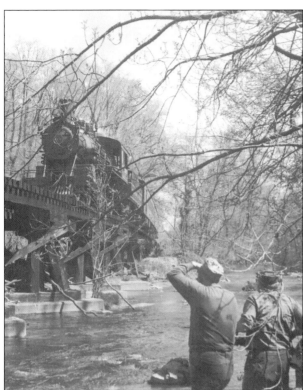

The Wilmington and Western Railroad right-of-way offers several prime locations for photographers, including several trestles that provide a unique setting characteristic of the line. These gentlemen take advantage of a beautiful spring day to capture an image of Locomotive No. 98 crossing Bridge 12B near Yorklyn. (Courtesy of HRCV, Inc.)

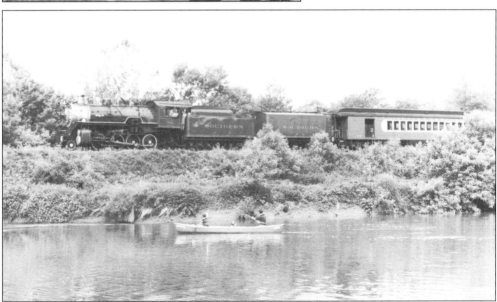

In the late 1970s, a cooperative tour of Brandywine Valley museums was inaugurated by the Wilmington and Western Railroad. Museums and gardens along the Brandywine River were showcased to promote historical interest. This photograph was taken on Memorial Day weekend in 1979 when Wilmington and Western Railroad Locomotive No. 722 traveled from Chadds Ford, Pennsylvania, to Winterthur Station, Delaware, carrying passengers that took part in this special event. (Courtesy of HRCV, Inc.)

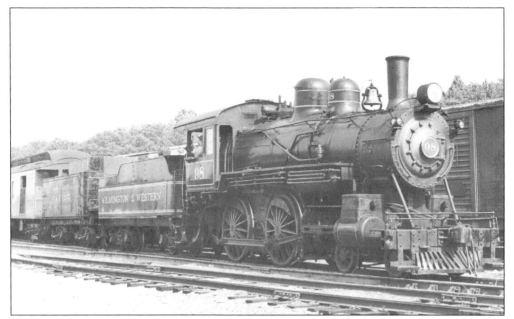

Locomotive No. 98 awaits passage through the Wilsmere Yard of CSXT at Elsmere, Delaware. In order to travel off-line, Wilmington and Western must first pass through this busy yard. This photograph was taken on the return trip to Marshallton, Delaware, from a day trip on the Octoraro Railway. The date is unknown. (Courtesy of Brian R. Woodcock.)

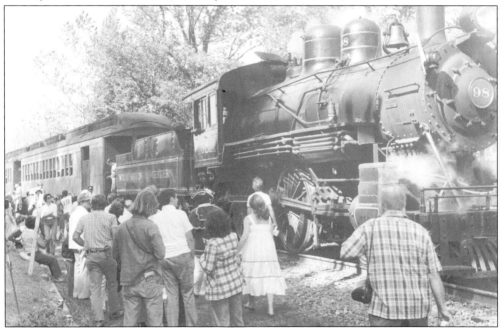

The Wilmington and Western Railroad participated in the Chadds Ford Fair in Chadds Ford, Pennsylvania, during the weekend of September 11, 1977, by operating steam excursion trains through the Brandywine Valley. The schedule required the trains to depart from Chadds Ford Junction to Lenape, Pennsylvania, and return. Trains ran on the hour from 11:00 a.m. to 7:00 p.m. Tickets prices were $3 for adults and $2 for children. (Courtesy of HRCV, Inc.)

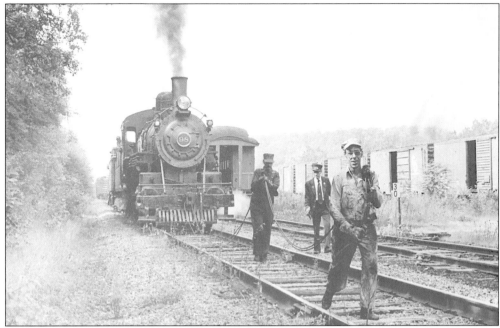

Wilmington and Western Railroad crewmembers fireman John Jeppi (front) and Frank Ferguson (back) prepare to perform an unusual run-around at the South Modena Yard in Coatesville, Pennsylvania, while conductor Earl Payne, dressed in uniform, observes the move. The passing track was partially blocked; in order to facilitate the move, the crewmembers resorted to using cables to pull the coaches past a switch. (Courtesy of HRCV, Inc.)

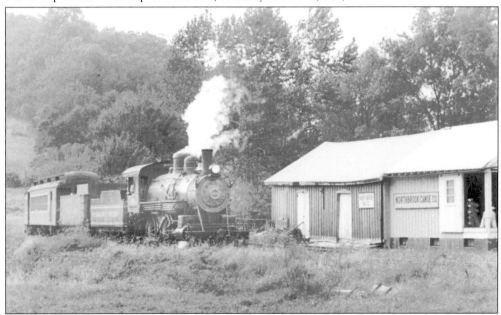

On July 30, 1977, Locomotive No. 98 arrived at its final destination of Northbrook, Pennsylvania. On this day, the Wilmington and Western delighted passengers with an off-line excursion on the tracks of the Wilmington and Northern. Excursions of this type were common in the 1970s, declined in the 1980s, and ceased completely in the 1990s. (Courtesy of HRCV, Inc.)

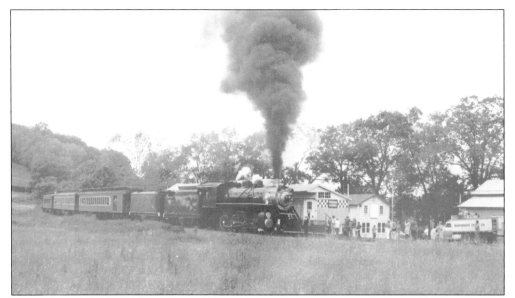

Southern Railroad Steam Locomotive No. 722 was leased by HRCV, Inc., for trips on the Wilmington and Northern branch during the late 1970s. This photograph was taken Memorial Day weekend in 1979 during an excursion to Northbrook, Pennsylvania. Run-bys were added to the trip for the benefit of photographers. (Courtesy of Brian R. Woodcock.)

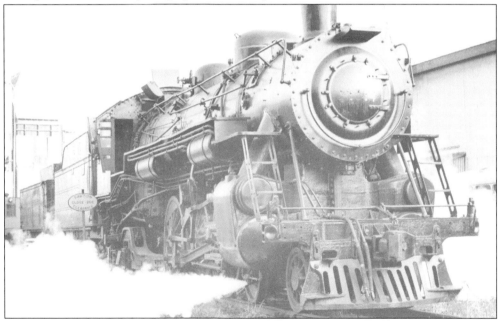

The Gulf, Mobile, and Northern 4-6-2 Locomotive No. 425 was built by Baldwin Locomotive Works in January 1928. It was renumbered No. 580 for the Gulf, Mobile, and Ohio Railroad. Paulsen Spence purchased this locomotive for the Louisiana Eastern Railroad in 1950, where it became No. 2 and then later No. 4. Malcolm Ottinger acquired it in 1963 and later sold it to Melvyn E. Small Jr., Brian R. Woodcock, and Wayne Rider in 1975. The new owners moved it to the Wilmington and Western in Marshallton, Delaware. This locomotive is no longer at the Wilmington and Western Railroad. (Courtesy of HRCV, Inc.)

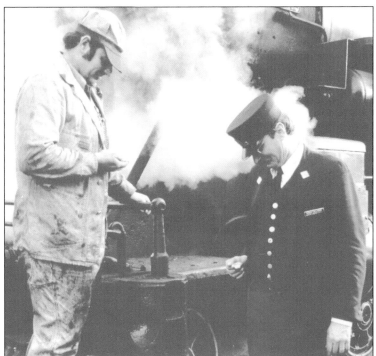

Wilmington and Western Railroad engineer Steven L. Jensen (left) and conductor Donald Callendar synchronize watches before leaving Marshallton Yard. (Courtesy of HRCV, Inc.)

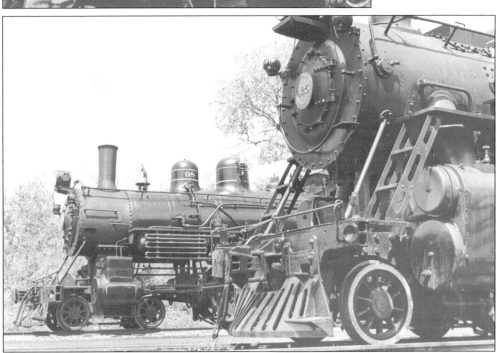

Locomotives Nos. 98 and 425 line up outside the Wilmington and Western engine house at Marshallton. Both locomotives were previously owned by Paulsen Spence, operator of the Louisiana Eastern Railroad. Prior to his death in 1961, his collection of steam engines numbered 37. All but four of the engines were sold for scrap. Two were taken to Stone Mountain Railroad in Georgia; the other two are seen here. (Courtesy of HRCV, Inc.)

Volunteers for the Wilmington and Western Railroad assist with the maintenance of the equipment. In this photograph, William Fessenden uses a steam hose to clean Locomotive No. 425 at Marshallton during the 1978 operating season. (Courtesy of HRCV, Inc.)

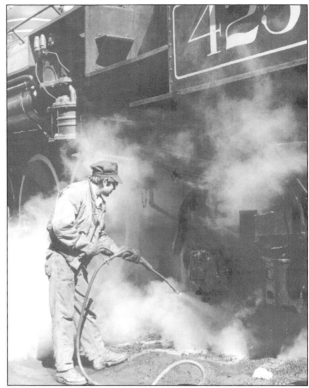

Locomotive No. 425, sporting new paint, pulls in to Greenbank Station to prepare for another day's excursion. Seen to the right is the baggage platform for the relocated Yorklyn station, and further in the rear is the Wilmington and Western elevated water tower. This water tower was originally built in 1966 and required new support legs in the summer of 2007. Locomotive No. 425 no longer serves on the Wilmington and Western Railroad. (Courtesy of HRCV, Inc.)

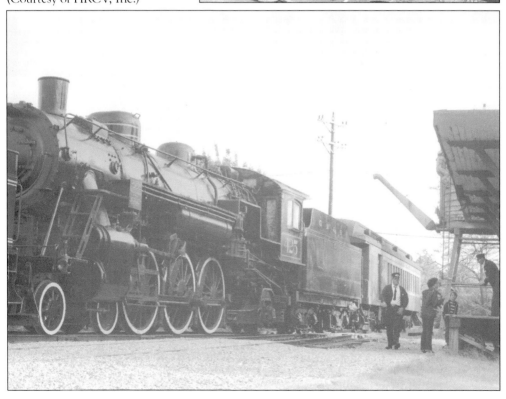

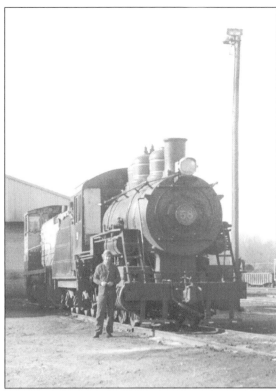

Brian R. Woodcock stands next to Locomotive No. 58 during a stop on the Reading Railroad during the move from Philadelphia to the Wilmington and Western Railroad. Woodcock purchased the locomotive from the Valley Forge Scenic Railroad in 1973 and generously donated it to HRCV, Inc., in 1998. (Courtesy of Brian R. Woodcock.)

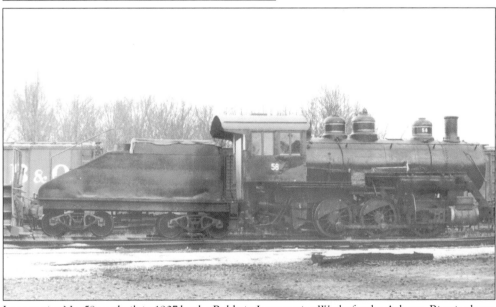

Locomotive No. 58 was built in 1907 by the Baldwin Locomotive Works for the Atlanta, Birmingham, and Atlantic and later became the Atlanta, Birmingham, and Atlantic No. 27. It was sold to the U.S. Army and renamed No. 6961. It was renamed again to No. 4 when it was owned and used by the Virginia Blue Ridge Railway. The Mead Corporation of Lynchburg, Virginia, acquired it and changed it to No. 300. Malcolm Ottinger purchased the locomotive in 1963 for the Valley Forge Scenic Railroad. (Courtesy of Brian R. Woodcock.)

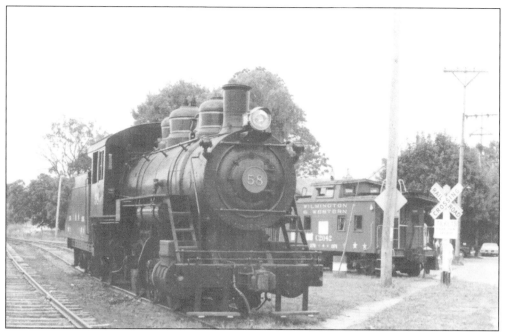

The Wilmington and Western Railroad participated in the U.S. bicentennial celebrations in Hockessin. Train rides from downtown Hockessin to the Delaware Nature Society at Ashland were offered during the three-day celebration. Caboose C-2042 was used as a ticket window, and Locomotive No. 58 was on display for visitors. (Courtesy of Brian R. Woodcock.)

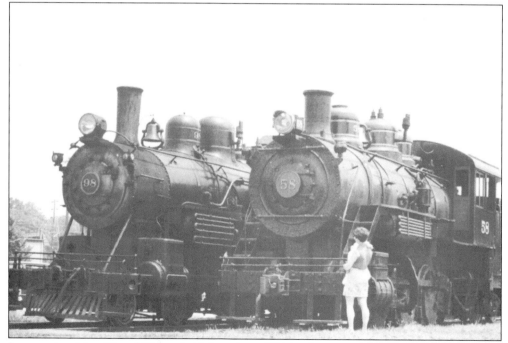

Locomotives Nos. 98 and 58 stand side by side in 1976 for the nation's bicentennial celebrations. Steam locomotive cab tours and historical interpretations were offered to visitors throughout the three-day event. (Courtesy of HRCV, Inc.)

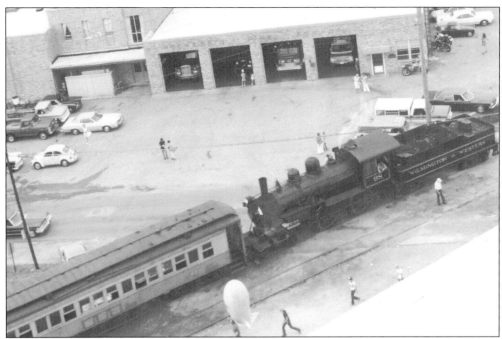

This aerial photograph taken on July 4, 1977, during the Independence Day celebrations in Hockessin shows No. 98 crossing Old Lancaster Pike. The Wilmington and Western Railroad provided six excursions on an hourly basis from downtown Hockessin to Ashland. Stops were made for transfers to the Magic Age of Steam at Yorklyn. As part of the celebration, helicopter rides, fire engine rides, and pony rides were offered to the public. (Courtesy of HRCV, Inc.)

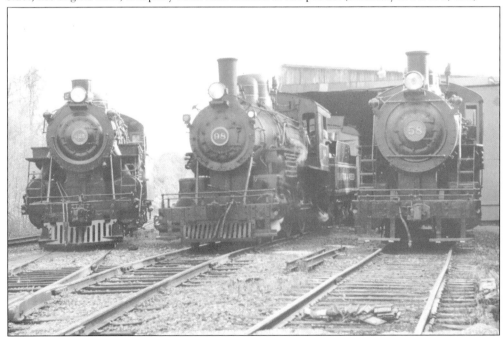

Locomotives Nos. 425, 98, and 58 are proudly displayed in anticipation of the arrival of guests. This 1978 photograph was taken at Marshallton. (Courtesy of HRCV, Inc.)

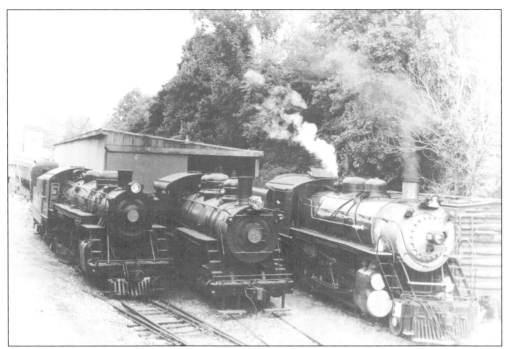

Former Gulf, Mobile, and Northern No. 425, along with former Atlanta, Birmingham, and Atlantic No. 58 and Southern Railway No. 722, all built by Baldwin Locomotive Works, line up in the yard for an open house at Marshallton in July 1979. (Courtesy of HRCV, Inc.)

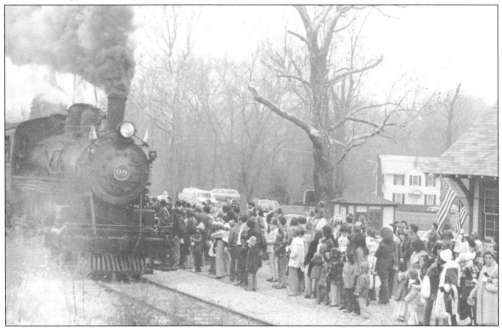

Crowds line up in front of the Wilmington and Western Kennedyville Station awaiting the arrival of Locomotive No. 98. The setting for this photograph is the holiday season Santa Claus Express train. Santa Claus excursions continue to be one of the most popular rides on the Wilmington and Western Railroad. (Courtesy of HRCV, Inc.)

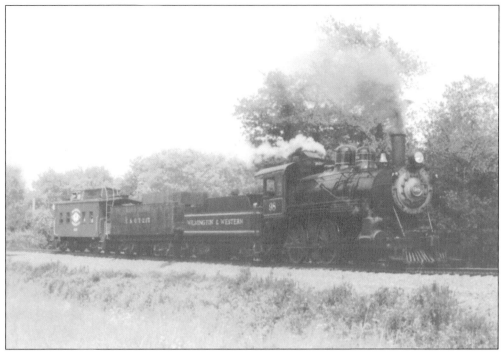

This photograph was taken in June 1980 when the Wilmington and Western No. 98 steamed along the Wilmington and Northern Railroad en route to the Octoraro Branch of the PRR. Later that day, No. 98 would arrive for the first time in Kennett Square, Pennsylvania. (Courtesy of Brian R. Woodcock.)

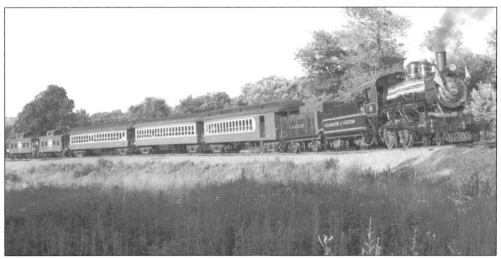

Wilmington and Western Railroad Locomotive No. 98 with three coaches and two cabooses lays over at Chadds Ford, Pennsylvania, for a rare photograph on July 4, 1980. The Wilmington and Western Railroad attended the festivities organized to commemorate the 125th anniversary of the founding of Kennett Square and the 204th anniversary of the nation's independence. (Courtesy of Brian R. Woodcock.)

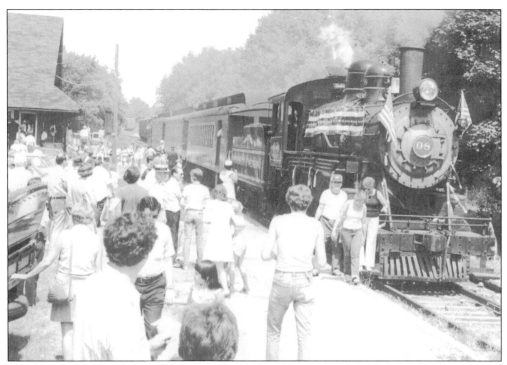

Wilmington and Western Railroad Locomotive No. 98 is pictured in Kennett Square on July 4, 1980. Thomas C. Marshall Jr., charter member of HRCV, Inc., is in attendance. Marshall stands at the left center wearing a straw hat. The train stopped at Kennett Square to pick up passengers traveling to Avondale, Pennsylvania. (Courtesy of HRCV, Inc.)

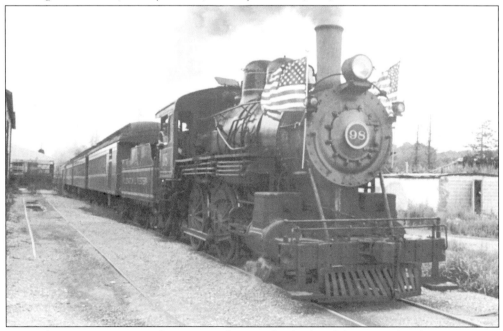

A year later, No. 98 again takes part in the Fourth of July celebrations, shuttling passengers between Kennett Square and Avondale, Pennsylvania. (Courtesy of HRCV, Inc.)

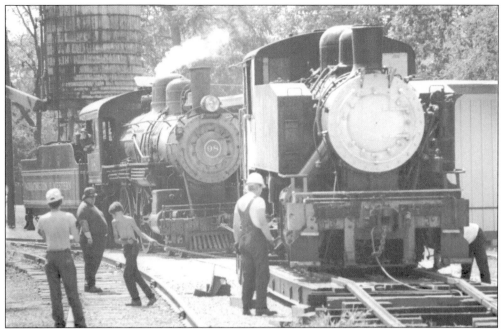

In 1980, the Wilmington and Western Railroad received Locomotive No. 3 at Greenbank. The steam engine was transported from Concordville, Pennsylvania, on a special gooseneck highway trailer. Upon arrival at Greenbank, the locomotive was unloaded on a spur track and towed to Marshallton by Locomotive No. 98. (Courtesy of HRCV, Inc.)

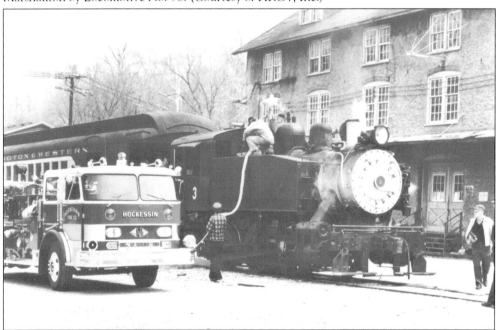

This Wilmington and Western Railroad excursion train pulled by Locomotive No. 3 stops briefly at Yorklyn to replenish the water in its tender. The Hockessin Fire Company aided the engine crew by providing a fast water supply. The train was part of the Fourth of July celebration. Passengers boarded the train at Hockessin, traveled to Ashland, and returned. (Courtesy of HRCV, Inc.)

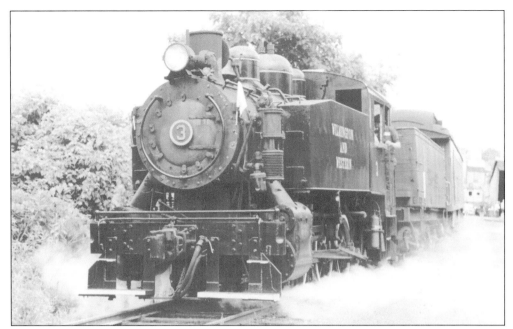

Wilmington and Western Railroad Locomotive No. 3 was built by Vulcan Locomotive Works in Wilkes Barre, Pennsylvania. Built for the U.S. War Department, it served in the Philadelphia Navy Yard. In 1962, it was purchased by the Wawa and Concordville for a newly formed tourist operation in Wawa, Pennsylvania. The locomotive was purchased in 1976 and eventually moved to Marshallton in 1980. This locomotive is no longer owned by HRCV, Inc. (Courtesy of HRCV, Inc.)

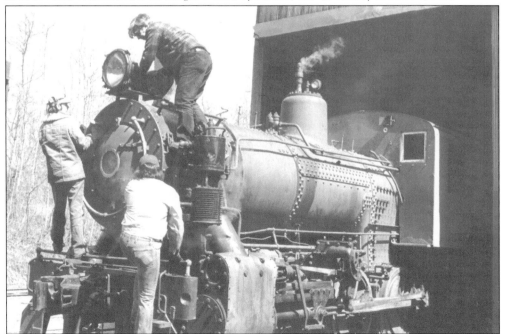

This photograph was taken in 1982 at Marshallton after a scheduled inspection was successfully completed on Locomotive No. 3. Brian R. Woodcock adjusts the headlight over the smoke box, assisted by David Jensen (left) and Thomas Gears (right). (Courtesy of HRCV, Inc.)

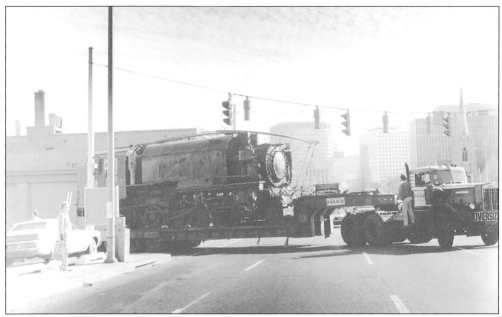

Locomotive No. 37, a 2-8-2T, was moved from Concordville, Pennsylvania, to Greenbank, Delaware, by truck. This photograph was taken in 1980 while the truck carrying the locomotive traveled through downtown Wilmington after exiting Interstate 95 en route to Greenbank Station. (Courtesy of Brian R. Woodcock.)

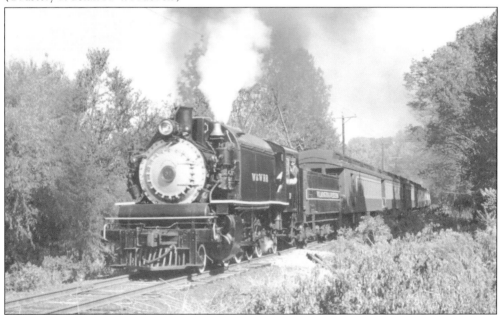

Locomotive No. 37, a 2-8-2T, was built by ALCO in Schenectady, New York, in 1924 with builder plate No. 66033. The locomotive was originally owned by the Sugar Pine Lumber Company as No. 4; it was sold in 1935 to the Pacific Lumber Company and renumbered No. 37. Frank Bayliss purchased the engine in 1962; subsequently it was sold to the Wawa and Concordville Railroad in 1966. In 1976, HRCV, Inc., member Melvyn E. Small Jr. purchased the locomotive; it was moved to Marshallton, Delaware, in 1980 and leased to HRCV, Inc. (Courtesy of HRCV, Inc.)

Three

OWNERSHIP OF THE LINE
1982–2007

On June 24, 1982, HRCV, Inc., along with officials of the Chessie System (the former B&O Railroad) signed a purchase agreement for the Landenberg Branch. The Interstate Commerce Commission approval became effective on August 2. August 13 was the last day the Chessie System controlled the line, transferring operations and maintenance responsibilities to HRCV, Inc. Besides the equipment and buildings, HRCV, Inc., now owned 10.2 miles of track, 22 bridges and trestles, and numerous parcels of real estate to operate on. In 1984, the position of executive director was created to keep up with the demands of an operating railroad. Today the organization has four paid employees who hold the positions of executive director, executive assistant, chief mechanical officer, and mechanic.

Operations of the Wilmington and Western Railroad are marked by constant rolling stock maintenance and restoration projects, construction of new buildings, and track and bridge improvements. The days of off-line excursions along the Wilmington and Northern, as well as Doodlebug to Harrington, Delaware, became virtually nonexistent. In the 1980s, local trips to Mount Cuba and Hockessin gained in popularity. Local volunteer Raymond Harrington and his rough talking group of actors amused and entertained passengers during their interpretation of a Wild West robbery. Civil War reenactments also proved to be big crowd pleasers. Weekday school trains were first offered in the 1970s and still provide short, educational trips today. The ever-popular Easter Bunny and Santa Claus Express trains continue sell out year after year. Passengers riding the Wilmington and Western Railroad are treated to the soothing motion of the train as it winds along the tranquil Red Clay Creek. Riders relax in the warm spring air, take in the pleasure of a summer picnic, and watch the beautiful colors of the fall foliage. The Wilmington and Western Railroad right-of-way is regarded as one of the most scenic rail lines in the eastern United States.

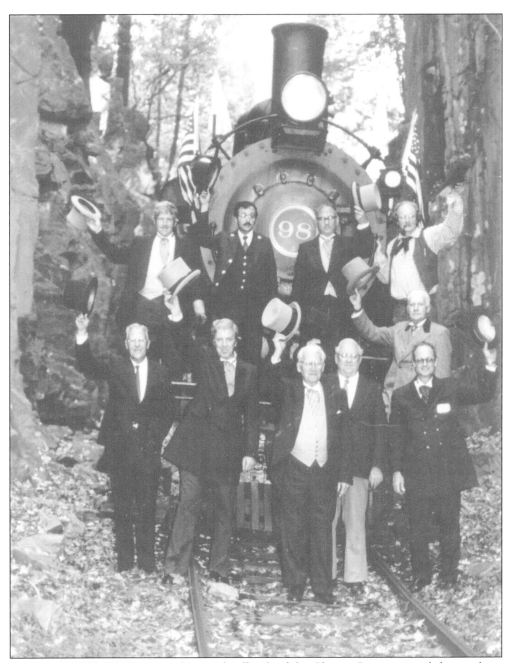

On June 24, 1982, HRCV, Inc., along with officials of the Chessie System, signed the purchase agreement for the Landenberg Branch. Later that summer, on September 19, 1982, officers of HRCV, Inc., pose at the Mount Cuba Rock Cut to commemorate the purchase of the Landenberg Branch. The above photograph is a recreation of an earlier commemorative photograph from 1875. From left to right are (first row) Thomas C. Marshall Jr., Brian R. Woodcock, Peter Steele, Leroy J. Scheuerman, John M. Iwasyk, and (immediately behind) Henry Dickinson Jr.; (second row) Melvin E. Small Jr., Francis Panariello III, Robert H. Spencer, and Donald W. Callendar Jr. (Courtesy of HRCV, Inc.)

In this photograph, the engine crew stands on the front of Locomotive No. 98 at Mount Cuba Rock Cut on September 19, 1982. Pictured from left to right are (first row) Steven L. Jensen, Michael Tillger, and Brian R. Woodcock; (second row) Melvyn E. Small Jr., Joseph Nelson, Thomas Gears, and Robert Becker. (Courtesy of HRCV, Inc.)

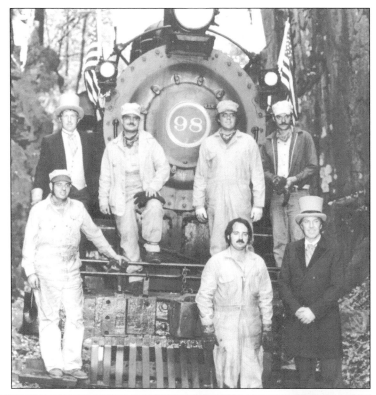

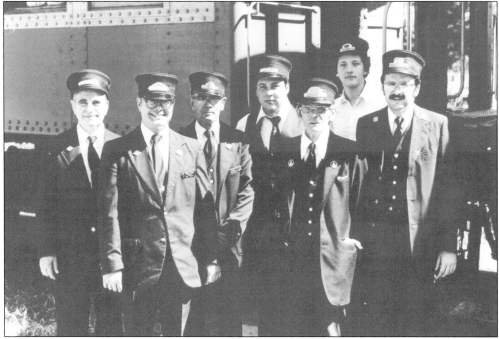

Volunteer trainmen are responsible for the safety and comfort of the passengers. Pictured from left to right are (first row) Gerald Snyder, Edward Berg, and Francis Panariello III; (second row) Leon Snyder, Earle Paine, Frank Cardile, and Raymond Harrington. (Courtesy of HRCV, Inc.)

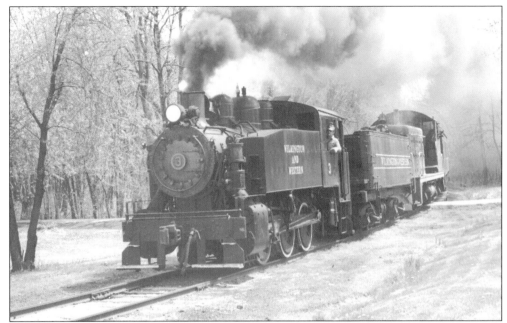

In this photograph, Locomotive No. 3 approaches the grade crossing at Lancaster Pike, Delaware Route 48. The grade crossing in the rear of the picture is a golf-cart crossing allowing golfers access to both sides of the Hercules (now Delaware National) Golf Course. This is one of the few railroad golf-cart grade crossings in the United States. The exact date of the picture is unknown. (Courtesy of HRCV, Inc.)

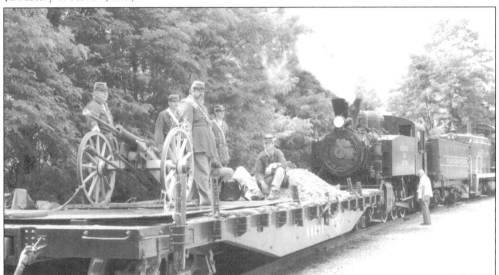

The Wilmington and Western Railroad holds many special events each year. Civil War Skirmish trains were among the most popular. In this photograph taken on June 7, 1986, with artillery mounted on a flatcar, the Civil War Special prepares to depart Greenbank Station enroute to Yorklyn. Behind the flatcar is Locomotive No. 3, followed by diesel Locomotive No. 8408. The diesel locomotive separated from the consist before reaching the open field that served as the battleground for a staged skirmish between the Union and Confederate forces. (Courtesy of HRCV, Inc.)

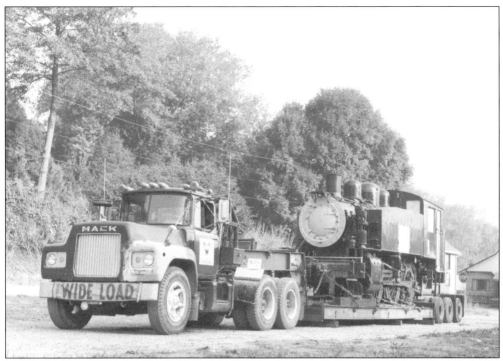

This photograph was taken in 1980 when Locomotive No. 3 was moved from Concordville, Pennsylvania, to Greenbank, Delaware, after being purchased. (Courtesy of HRCV, Inc.)

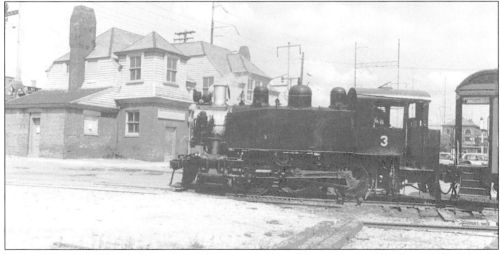

This photograph of Wilmington and Western Railroad's Locomotive No. 3 was taken during an extended stop at the foot of Market Street in Wilmington, Delaware, on May 25, 1983. The building on the left is the B&O depot built in 1880. Through the open vestibule of the coach on the right of the photograph, the present-day Amtrak Station in Wilmington can be seen. This locomotive with one coach and one caboose was used as a stage at the Amtrak Station in Wilmington for a short segment in a popular television show. The train remained in downtown Wilmington for two days. On May 27, Locomotive No. 3 and its consist participated in the rededication of the U.S. Coast Guard cutter *Mohawk* as a living museum dedicated to the marine battles in the North Atlantic. (Courtesy of HRCV, Inc.)

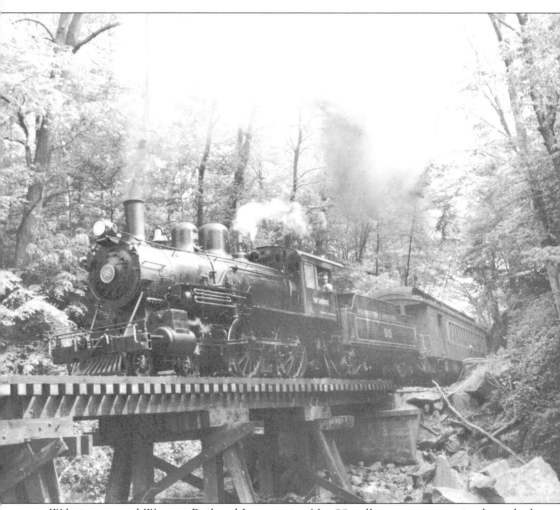

Wilmington and Western Railroad Locomotive No. 98 pulls a passenger train through the Wooddale Rock Cut in Wooddale on May 17, 1992. The Wooddale Rock Cut is the first of two large rock cuts through which passenger trains travel. This cut was blasted and cleared by hand in 1871 to make way for the railroad. In this precise area, two major geological formations can be found: the Wilmington Complex and the Wissahickon Formation. These two tectonic plates lifted millions of years ago and began the process that formed the Appalachian Mountains. Although the walls are dark today, chipping to expose fresh surface on the eastern wall of the cut reveals light-colored igneous rocks of the Wilmington Complex, and the western wall reveals the garnet-bearing metamorphosed sedimentary rocks of the Wissahickon Formation. (Courtesy of HRCV, Inc.)

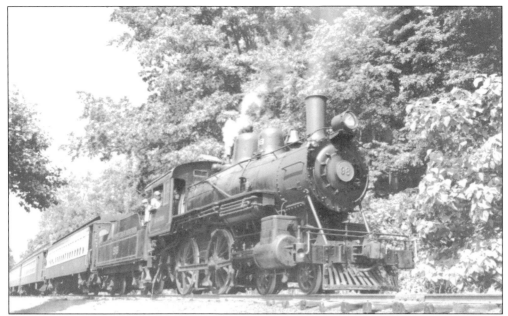

In this photograph by Edward J. Feathers, Locomotive No. 98 lays over for a Wild West Robbery train at Yorklyn on June 28, 1992. Actors entertained and amused passengers aboard the train and performed a staged confrontation between marshals and outlaws to sold-out trains. The crewmen on the locomotive are fireman John D. Wentzell (left) and engineer Steven L. Jensen (right). (Courtesy of HRCV, Inc.)

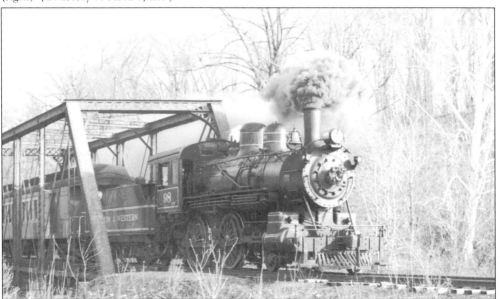

Locomotive No. 98, pulling one of the 1985 Santa Claus Specials, crosses over the iron through-truss bridge (11A) at Ashland. This is the only iron through-truss bridge on the Wilmington and Western Railroad. This bridge was originally one of the spans of B&O Wheeling Division Bridge No. 124. It was moved and placed over the Red Clay Creek in 1907. The bridge spans 104 feet and is almost 18 feet wide and nearly 22 feet high. The design is known as a Pratt truss bridge. (Courtesy of HRCV, Inc.)

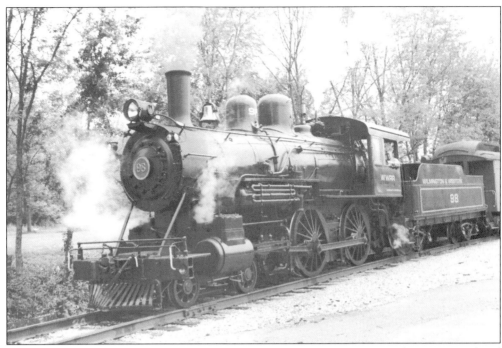

This photograph was taken on May 17, 1992, at Greenbank. Wilmington and Western Railroad Locomotive No. 98 is at Greenbank Station in preparation for the second trip scheduled for the day. (Courtesy of HRCV, Inc.)

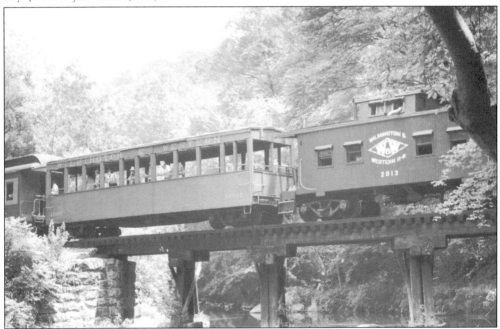

Bridge 8B is located near Lancaster Pike, Delaware Route 48. Not far from this location is the site of one of the U.S. Geological Survey water recording stations. Their purpose is to monitor and record water flow and levels. The data are used to evaluate drought and flood conditions of the Red Clay Creek watershed. (Courtesy of HRCV, Inc.)

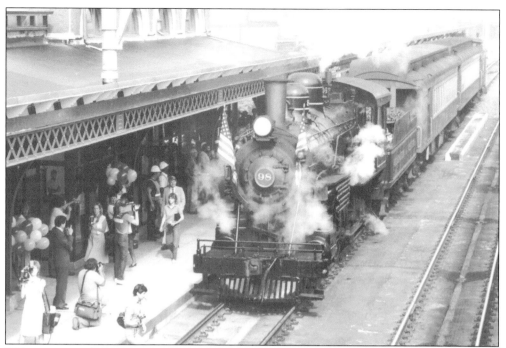

Wilmington and Western Locomotive No. 98 fascinates onlookers as it pulls in to the newly renovated Amtrak station in Wilmington in 1985. Amtrak officials invited the Wilmington and Western to display their equipment at the rededication celebration of this historic structure. (Courtesy of HRCV, Inc.)

Locomotive No. 98 departs the Amtrak station in Wilmington. The date is September 1997. Each year, the Wilmington and Western has participated in a Transportation Day event sponsored by Amtrak, the Delaware Department of Transportation, and other transportation-related entities. (Courtesy of HRCV, Inc.)

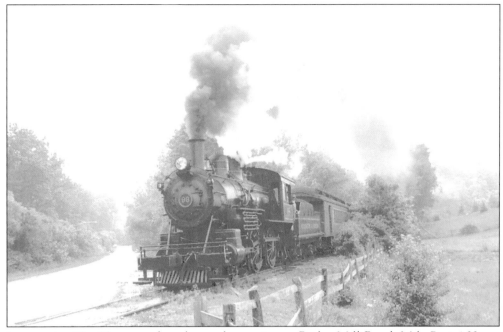

Locomotive No. 98 approaches the grade crossing at Barley Mill Road, Mile Post 4.33, on June 8, 1985. The Barley Mill tangent begins shortly after Spring Valley Road, a short distance behind the train. About half a mile long, this is the longest and straightest near-level section of track on the Wilmington and Western Railroad. (Courtesy of HRCV, Inc.)

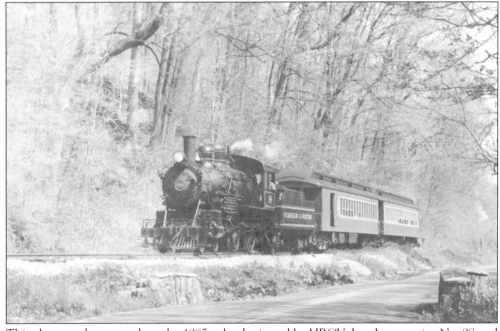

This photograph appeared on the 1985 calendar issued by HRCV, Inc. Locomotive No. 98 and two coaches pass on the straight stretch of track along Delaware Route 82 (Mile Post 7.0). This is a popular place for avid photographers in search of the perfect shot. This is also the location where the Yorklyn water tower once stood. (Courtesy of HRCV, Inc.)

Trips to the Mount Cuba Picnic Grove include a half-hour layover. In this 1977 photograph, a young child captures the moment with his instamatic camera. During the layover, minor service activities are performed by the crew, and crowds are able to ask questions and visit the locomotive cab. (Courtesy of HRCV, Inc.)

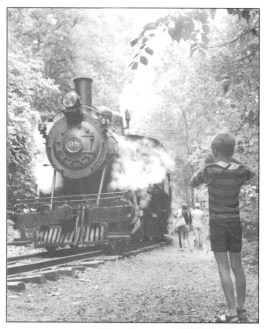

School trips were the largest community service activity during the operating season in the 1980s. The program was first conceived in 1968 by HRCV, Inc., president Peter Steele. Originally named Kindergarten Trips and limited to preschoolers, the program expanded to include elementary-school-age children. For most of the children, these excursions were their first exposure to a steam locomotive and this early mode of transportation. Although the steam locomotives were eventually replaced by diesel-electric locomotives, ridership has remained strong, and school and summer camp trains are still among the most popular of the Wilmington and Western excursions. In this 1983 photograph, a child protects his ears from the shrill blast of Locomotive No. 98's whistle. (Courtesy of HRCV, Inc.)

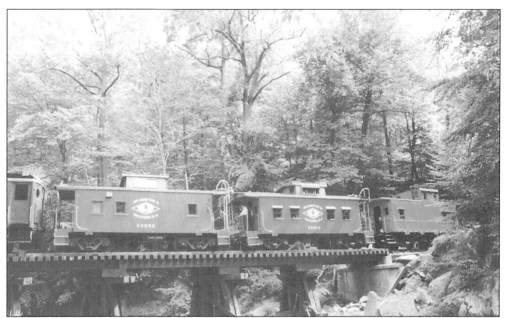

Wilmington and Western Railroad's three cabooses cross over Bridge 8B at Wooddale. On the bridge appearing from left to right are cabooses C-2042, C-2013, and C-149. C-2013 and C-2042 were built in 1926 by the B&O in Washington, Indiana. There were 401 Class I-5 wooden cabooses produced by the B&O. The two shown here were acquired by HRCV, Inc., in the 1960s. (Courtesy of HRCV, Inc.)

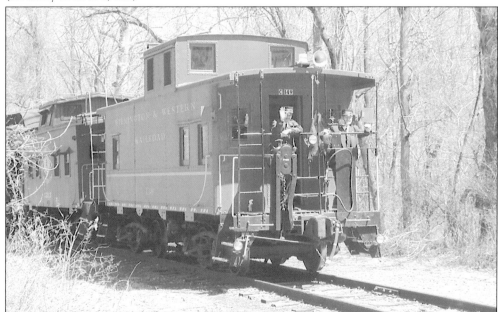

Caboose C-149 is one of 70 steel cabooses built in July 1941 at the Dunmore Shops of the Erie Railway. Several railroad mergers took place, and by 1976, C-149 was owned by Conrail. It became Class N-3 No. 46195. Originally these cabooses served as office and living quarters for train crew. Nowadays this caboose is frequently used to host well-liked birthday parties. This photograph was taken in April 2003. (Courtesy of Jose A. Vazquez.)

Birthday parties were first offered to passengers in the early 1970s. The cake and pink lemonade was provided by the railroad for the guests attending the celebration. Although refreshments are no longer provided, the birthday party cabooses are extremely popular with the children. (Courtesy of HRCV, Inc.)

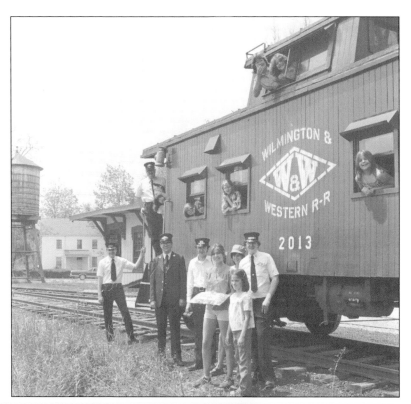

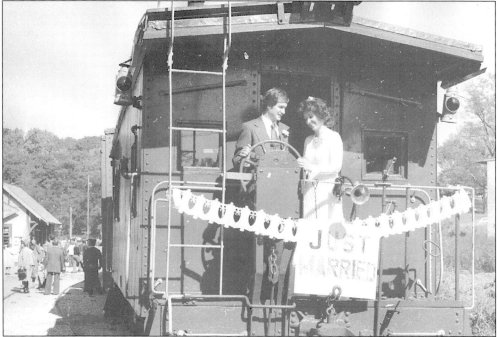

The first marriage the Wilmington and Western hosted was celebrated on October 21, 1979. The ceremony was conducted at the Mount Cuba Picnic Grove. Brides and grooms are delighted by the unique setting the railroad provides. (Courtesy of Brian R. Woodcock.)

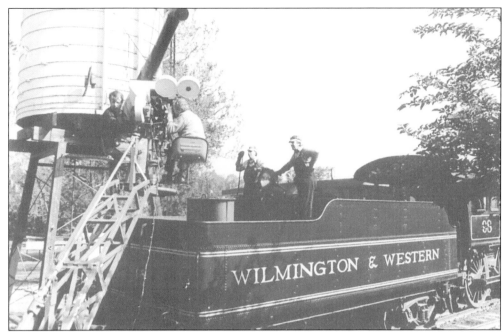

In 1983, Wilmington and Western Railroad Locomotive No. 98 had cameras installed on top of its tender. These cameras were used to produce a widescreen-stereo movie. In 2002, another movie was filmed using Locomotive No. 58. The 2002 movie was a fictional portrayal of historic events. (Courtesy of HRCV, Inc.)

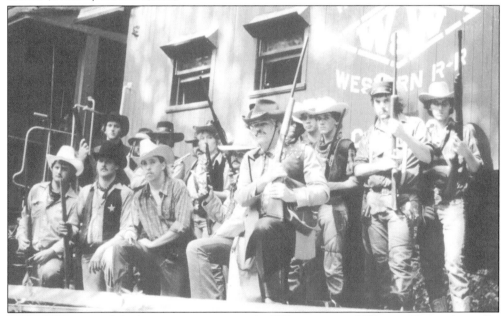

In the 1980s, one of the biggest attractions at the Wilmington and Western Railroad was the Wild West Robbery trains. A group of volunteer actors played out a scenario that included a gold shipment being hijacked by a gang of seedy outlaws. This gang continued to rob trains up until the mid-1990s. Recently, "Black Bart and his thugs" were back on the Wilmington and Western for a once-a-year repeat performance. (Courtesy of HRCV, Inc.)

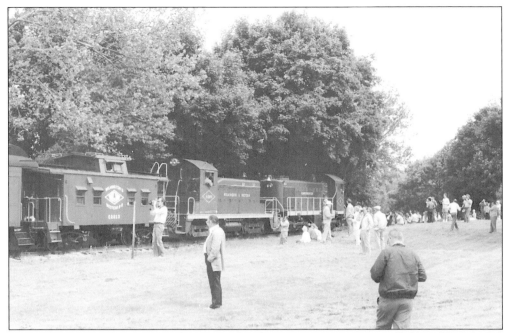

Shown here are Wilmington and Western diesel Locomotives Nos. 8408 (left) and D-3 (right) during a photograph stop in Pocopson, Pennsylvania. D-3, an ALCO S-1, was assigned the 'D' to differentiate it from Wilmington and Western steam Locomotive No. 3. This was the first of three Brandywine Valley Rail Rambles for the 1988 operating season. (Courtesy of HRCV, Inc.)

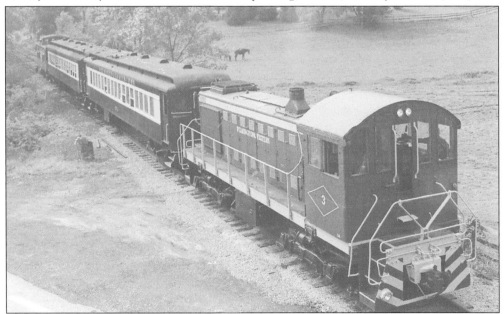

This photograph was taken in 1990 as diesel Locomotive No. D-3 approached the Barley Mill Road grade crossing. This was the last time the D-3 operated in regular passenger service during the 1990 operating season. The two coaches shown are MP-54 commuter coaches. One of these coaches was later transformed into an open-air car; the other is currently stored out of service. (Courtesy of HRCV, Inc.)

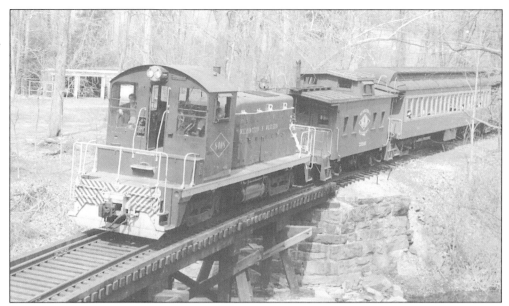

Diesel Locomotive No. 8408 is heading eastbound to Greenbank Station, returning from the Mount Cuba Picnic Grove in the spring of 1991. Built in 1940 by the Electro-Motive Division of General Motors in Chicago as No. 208, this SW-1 switcher was one of 16 delivered to the B&O. The six-cylinder, two-cycle locomotive has a tractive effort of 49,500 pounds. In February 1957, the number was changed from 208 to 8408 when the 200 series was changed to the 8400 series by the B&O. This locomotive still operates on the Wilmington and Western Railroad Landenberg Branch. (Courtesy of HRCV, Inc.)

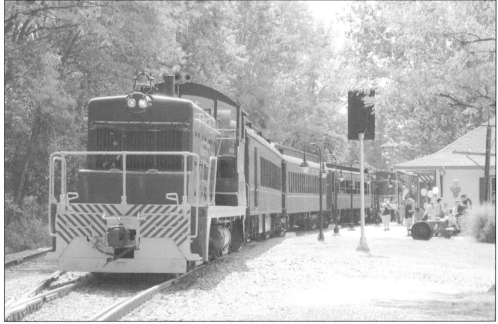

Locomotive No. 8408 awaits departure at Greenbank Station. Wilmington and Western substitutes diesel locomotives during the hot summer months to relieve crews from the sweltering heat of the steam locomotive cab. (Courtesy of B. Michael Ciosek.)

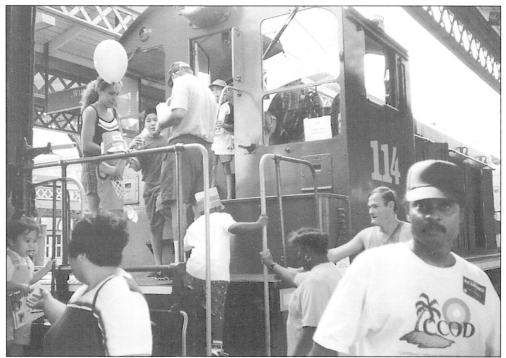

These photographs of diesel Locomotive No. 114 were taken on September 26, 1998, at the Amtrak Station in Wilmington. The Wilmington and Western Railroad participated in the 15th Annual Transportation Day. This event was organized by the Delaware Transit Corporation. Locomotive No. 114 was one of four engines opened to the public for tours. (Courtesy of HRCV, Inc.)

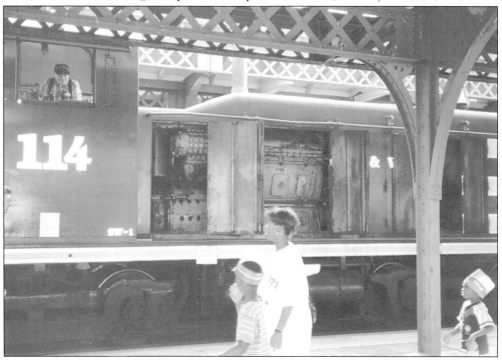

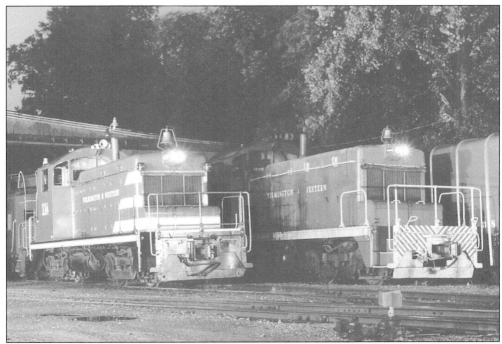

Locomotives No. 114 (left) and No. 8408 (right) are stationed outside the Wilmington and Western storage facility at Marshallton. This rare, staged event is for a private nighttime photo shoot. (Courtesy of HRCV, Inc.)

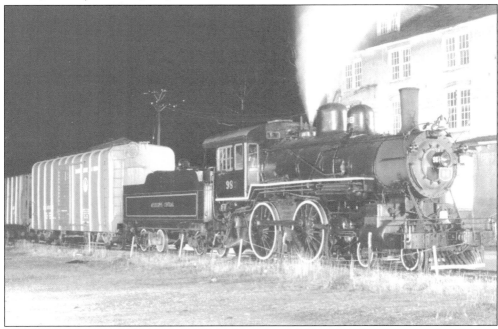

Locomotive No. 98 is pictured at Yorklyn on December 12, 1996, during a special nighttime photo event. The locomotive has been temporarily re-lettered to its original Mississippi Central lettering. The number plate, headlight, and a high-mounted bell on the smoke box, as well as a second bell, just below, were added to recreate No. 98's original look. (Courtesy of HRCV, Inc.)

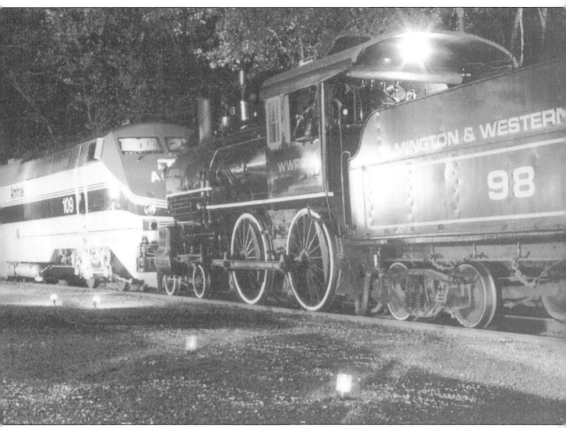

On October 18, 1997, Locomotive No. 98 met face-to-face with Amtrak P-42 Locomotive No. 109 at Greenbank. The staged setting was part of a ceremony scheduled for the 125th anniversary of the continuous operations of the Wilmington and Western Railroad on the Landenberg Branch. (Courtesy of HRCV, Inc.)

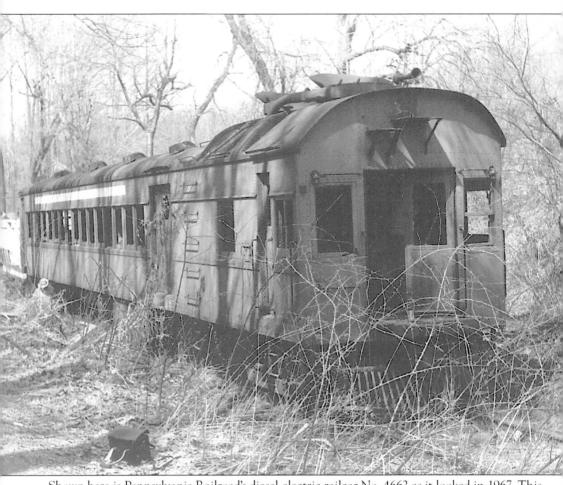

Shown here is Pennsylvania Railroad's diesel-electric railcar No. 4662 as it looked in 1967. This car was built in 1924 by the Pullman-Standard Car Company. It was powered by two Winton 175-horsepower, six-cylinder gasoline engines driving two General Electric 600-volt DC generators, which in turn fed two 160-horsepower General Electric traction motors. The original gasoline engines were replaced by two Cummins HBIS-6 175-horsepower diesel engines in 1942. This car saw service in Chadds Ford, Kennett Square, Lancaster, York, Baltimore, and Camden Rail Systems of the PRR. In 1959, it was removed from service. In 1962, the National Capitol Trolley Museum rescued the car from a scrap yard. Never used, it was stored in the open in North Baltimore, where it fell into disrepair and was vandalized. In 1967–1968, the No. 4662 was purchased by HRCV, Inc., through a generous gift of founding member Thomas C. Marshall Jr. and was moved to Marshallton. For the next 10 years, restoration work moved forward at an agonizingly slow pace. (Courtesy of HRCV, Inc.)

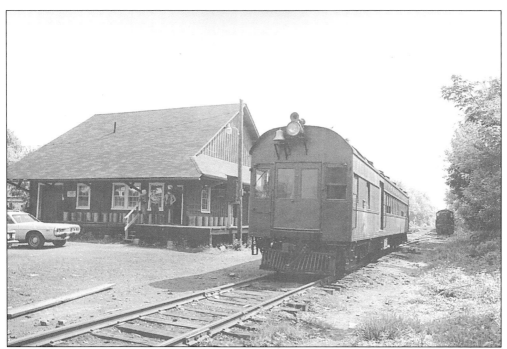

The ex-PRR No. 4662 arrives in Kennett Square enroute to Oxford, Pennsylvania, on May 17, 1980. To the left of No. 4662 is the original Kennett Square passenger station that was used as the offices of the Octoraro Railway. (Courtesy of HRCV, Inc.)

Ex-PRR No. 4662 travels over the Elkview Trestle outside of Jennersville, Pennsylvania, on May 17, 1980. This excursion was sponsored by a private rail fan group that took No. 4662 onto the Wawa-Colora Branch of the Pennsylvania Railroad through the communities of Kennett Square, Toughkenamon, Avondale, West Grove, Kelton, Elkview, and on into Oxford, Pennsylvania. (Courtesy of HRCV, Inc.)

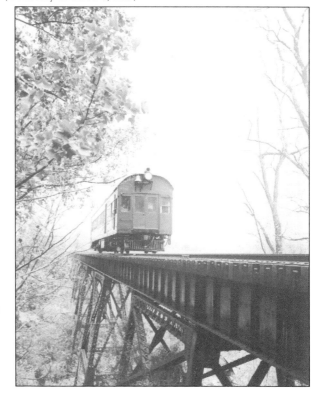

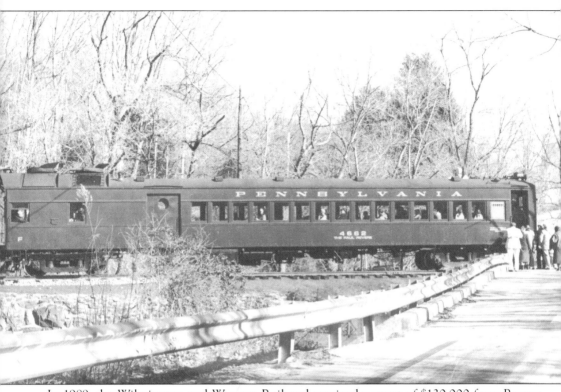

In 1989, the Wilmington and Western Railroad received a grant of $130,000 from Revere Copper and Brass, Inc., to restore the ex-PRR No. 4662 gas car, also known as a Doodlebug. The restoration project consisted of new diesel engines, replacement of the couplers and draft system, and modifications to the air brake systems. The work was performed at the Delaware Car Company in Wilmington. Once completed, the car was returned to Marshallton where Wilmington and Western volunteers restored the interior of the car, being careful to maintain its historical appearance and features. On June 7, 1990, the ex-PRR No. 4662 was renamed the *Paul Revere* during a dedication ceremony that took place at Greenbank Station. The above photograph was taken on January 19, 1991, at Sharpless Road (Mile Post 6.9). Passengers of a private charter prepare to board the car after a run-by photo opportunity. (Courtesy of HRCV, Inc.)

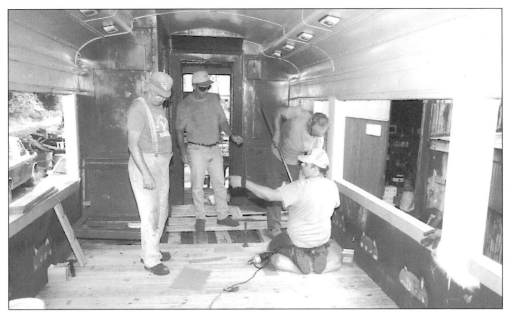

The Wilmington and Western right-of-way traverses rolling countryside with deciduous hardwood forests and private estate lands. To fully appreciate that experience, one must see the vista in an unobstructed way. Here Wilmington and Western volunteers convert an aging Pennsylvania Railroad Class MP-54 passenger coach into an open-air car. From left to right, (front) James Owens and Steven L. Jensen; along with (back) David Ludlow and Leonard Beck build and install the new floor for the open car. (Courtesy of HRCV, Inc.)

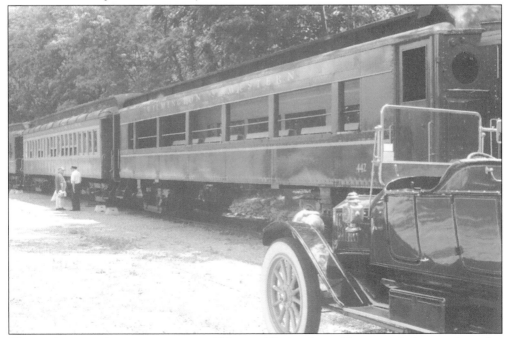

The newly restored open-air car named *Kiamensi Springs* has wide-open windows and wooden bench-style seating for passengers. It is one of three MP-54 coaches known to operate in tourist line service. It is used primarily during the summer and fall. (Courtesy of HRCV, Inc.)

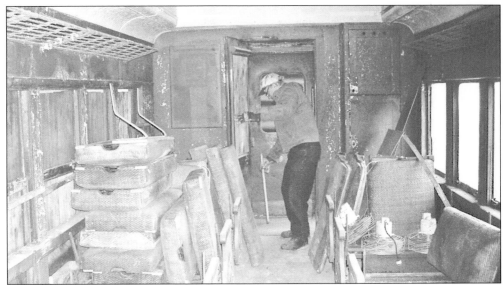

Volunteer Leonard Beck removes cushions and seat frames from an ex Erie-Lackawanna passenger coach. The car was built in 1930 for the Delaware, Lackawanna, and Western Railroad and numbered 2548. In 1960, it became the Erie-Lackawanna No. 3548. The Wilmington and Western Railroad acquired it in 1991 and placed it in storage. In the summer of 2006, staff members and dedicated volunteers began to convert this coach into a parlor car. The car was lettered and numbered Pennsylvania-Reading Seashore Line No. 6795 by a previous owner, even though it was never owned by that railroad. (Courtesy of Gisela Vazquez.)

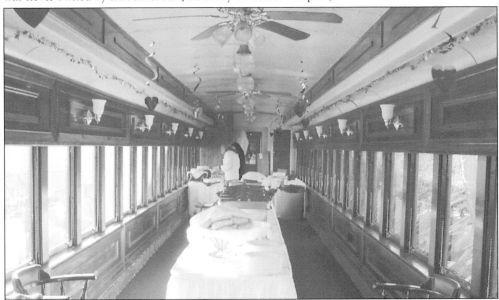

This is a view of the refurbished Parlor Car No. 6795 after the interior was modified. Wood panels cover the walls, the ceiling and roof have been replaced, new wiring was installed, paint was removed from the window frames to expose shiny brass, and the floor was covered with carpet. New lighting, fans, and heating lines were also installed to allow for year-round use. After nine months of work, the car was returned to service on September 21, 2006. (Courtesy of Gisela Vazquez.)

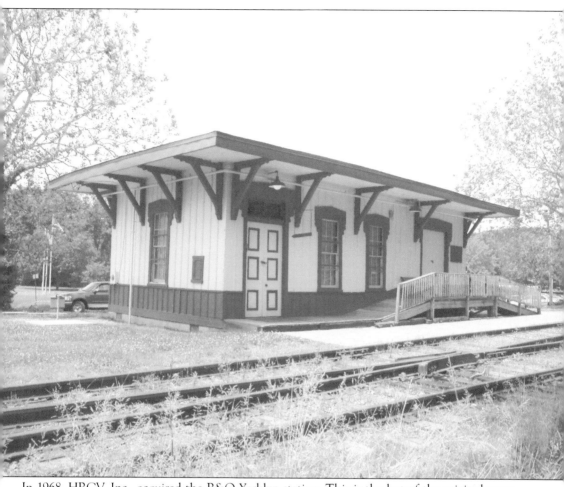

In 1968, HRCV, Inc., acquired the B&O Yorklyn station. This is the last of the original seven identical passenger stations built by the first Wilmington and Western Railroad in 1873. Originally painted a barn-red color, it was repainted brown and yellow in 1883 when the B&O purchased it. The frame structure was built to provide passenger and freight service in the flourishing community of Yorklyn (formerly Auburn). The building was constructed on two levels. The ground floor was for the freight agent's office, ticket counter, and waiting area; the second level was raised slightly to allow the transfer of baggage and goods into the baggage cars or freight cars without having to lift the load. On July 25, 1998, the Yorklyn station opened as the Red Clay Valley Museum and Visitors Center, which displays a large collection of items and artifacts related to the Wilmington and Western Railroad and Brandywine Springs Park. (Courtesy of B. Michael Ciosek.)

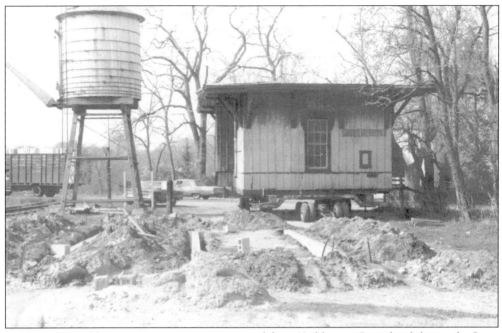

In 1968, the Yorklyn passenger station was moved from Yorklyn to Greenbank by truck. Once the station arrived at Greenbank, its foundation had to be completed before placing the building at its new permanent location. The site that was chosen is close to where the original B&O Greenbank station once stood. (Courtesy of HRCV, Inc.)

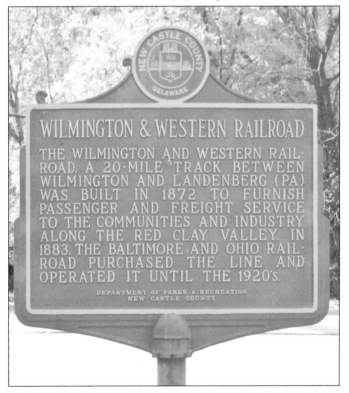

On September 8, 1980, the Wilmington and Western Railroad was listed on the National Register of Historic Places, administered by National Park Service. All of the railroad's rolling stock, right-of-way, tracks, and bridges were made part of the designation. This historic marker, located at Greenbank station next to the Red Clay Valley Museum and Visitors Center (the former Yorklyn station), was erected by the New Castle County Parks Department to further recognize the importance of the Wilmington and Western Railroad. (Courtesy of Gisela Vazquez.)

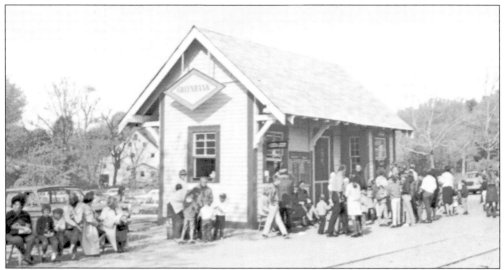

The former PRR Kennedyville passenger and freight station was previously located in Kennedyville, Maryland. In 1963, HRCV, Inc., purchased it for $1. The building was dismantled into sections, transported to Delaware, and stored until 1965. The station was reconstructed at the Wilmington and Western passenger platform known as Greenbank station and served as a ticket window and snack bar until 1997. This postcard is one of several that HRCV, Inc., produced depicting structures and equipment owned and operated by the Wilmington and Western Railroad. The date of this photograph is around 1968. (Courtesy of HRCV, Inc.)

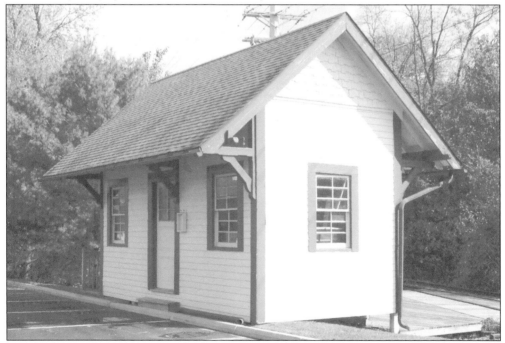

The former Kennedyville station is presently located in Hockessin. In 1997, the structure was once again cut into sections and moved from Greenbank to Hockessin, where it was reassembled. At the present time, it is closed to the public and is preserved for historical purposes. (Courtesy of Gisela Vazquez.)

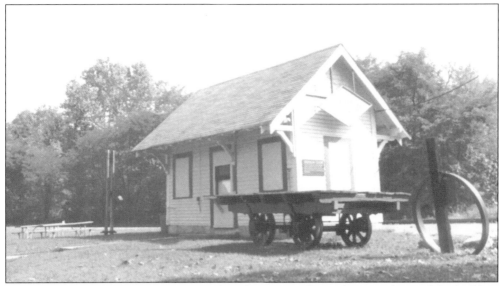

This is Greenbank station as it appeared in the 1980s. The push car in front of the building was built around 1904 and was acquired from the Worth Brothers Company in 1966. It was previously used at the Garrett Snuff Mills (1782–1954) in Yorklyn, Delaware, to aid mill workers transporting materials between buildings. It operates on standard-gauge tack. From 1966 until 2005, the car was displayed at Greenbank station for educational purposes. After years of being exposed to the weather, the car showed severe damage and was removed from public view and fully restored. Currently, it is being kept in storage. The big ring on the right of the photograph is a steam locomotive tire. (Courtesy of HRCV, Inc.)

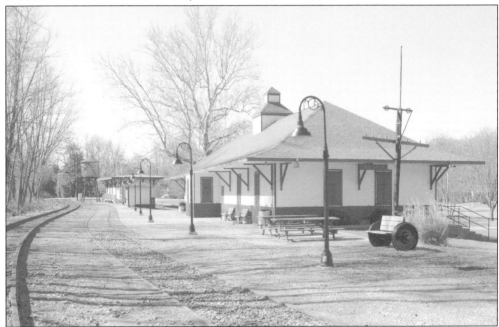

In 1997, a new station was constructed at Greenbank to serve the Wilmington and Western Railroad. This 3,000-square-foot building has a gift shop, ticket counter, facilities, and a meal depot. (Courtesy of Jose A. Vazquez.)

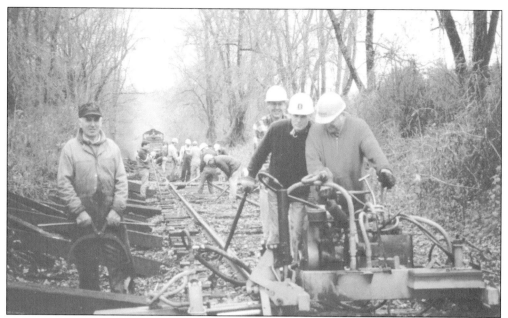

Members and volunteers of HRCV, Inc., gathered on November 11, 1997, to celebrate the 125th anniversary of operations on the Landenberg Branch by replacing 125 railroad ties in one day. The location of this record event is the Barley Mill stretch (Mile Post 4.35). Among the members present are Henryk Twardowski (left) and to the right on the tie inserter (from front to back), William Houser, Peter O. Lane, and unidentified. (Courtesy of HRCV, Inc.)

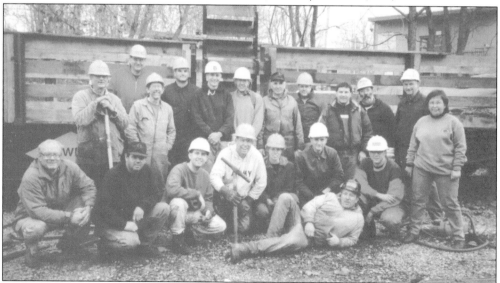

Members and volunteers of HRCV, Inc., pose for a picture at the end of the day on November 11, 1997. This group made the goal of 125 ties replaced plus two extra during the 125th anniversary. These members and volunteers are, from left to right, (front) David S. Ludlow; (first row) Leonard Beck, Steven L. Jensen, Brian Crozier, Gene Tucker, Deborah Tucker, Keith Anzilotti, Wayne Sohlman, and Carole R. Wells; (second row) Dr. John Iwasyk and Marty Drinan; (third row) William Houser, unidentified, Peter O. Lane, unidentified, Henryk Twardowski, Curtis W. Cox, Scott Bieber, John Oscar, and Donald Morrison. (Courtesy of HRCV, Inc.)

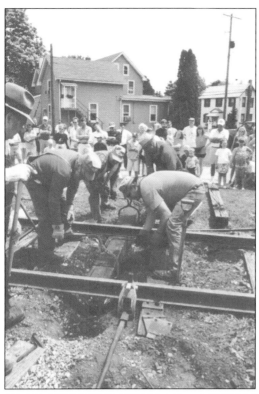

The Wilmington and Western Railroad Maintenance-of-Way Days were part of the regularly scheduled excursion trips to Hockessin. Track workers demonstrated to the passengers how crosstie replacement was performed in the pre- and post-mechanized eras. Track members demonstrate the traditional, time-honored, hand method of replacing a crosstie. At front left is Edward Hoffmeister, and from left to right are (first row) John Oscar and Steven L. Jensen; (second row) Leonard Beck and John Iwasyk. (Courtesy of HRCV, Inc.)

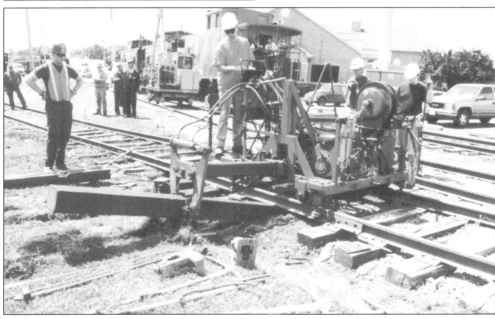

Track worker Brian Crozier manipulates the Wilmington and Western Tie Master. This machine is capable of pulling out the old spikes, removing the old crosstie, inserting the new tie, and driving in the new spikes. Amazingly, when competing with the traditional hand-removal method on a one-to-one basis, both are equally productive. It is only when volume is considered that the Tie Master far exceeds the traditional way. (Courtesy of HRCV, Inc.)

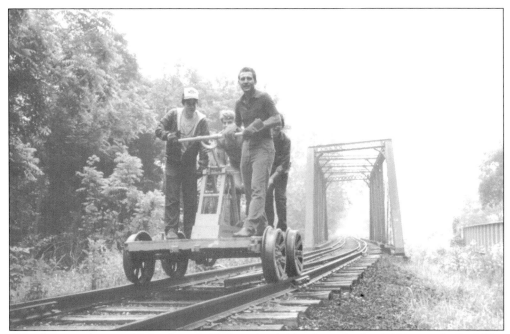

This photograph was taken on June 9, 1985, at the Ashland iron bridge (11A) over the Red Clay Creek. From left to right are (first row) Donald Richards and Ronald Keith; (second row) Timothy Fulton and ? Broadwater. The group powered the antique Wilmington and Western handcar from Hockessin to Marshallton. (Courtesy of HRCV, Inc.)

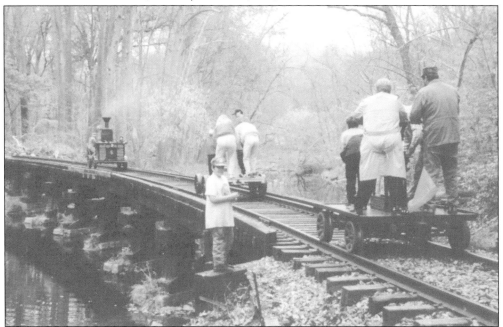

On November 1, 1998, the Wilmington and Western Railroad hosted a special event that featured velocipedes, handcars, and steam- and gas-powered track inspection cars. Visitors that day took the train from Greenbank to Mount Cuba, where the various cars were on display. Short rides were offered for the passengers' enjoyment. (Courtesy of HRCV, Inc.)

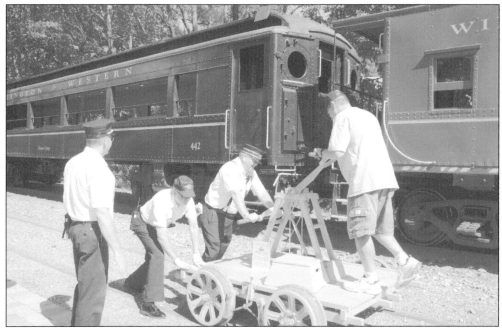

This handcar is a manually propelled maintenance vehicle used by track maintenance gangs and inspectors prior to the introduction of gasoline-driven vehicles. Its operation is simple but physically demanding. One or two men pump handles up and down to turn a flywheel and propel the car along the tracks. (Courtesy of HRCV, Inc.)

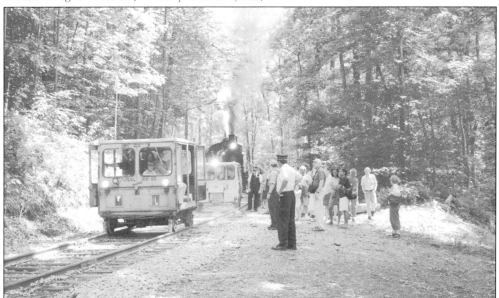

The Wilmington and Western Railroad has hosted Speeder Days since the mid-1980s. These railroad motorcars, also knows as "speeders," are significantly faster than the manually operated handcars. They operate on gasoline engines, and some models can reach a maximum speed of 35 miles per hour. These cars were used for track inspections until they were replaced by Hy-Rail trucks. In this photograph, two speeders depart from Mount Cuba Picnic Grove. (Courtesy of Edward J. Feathers.)

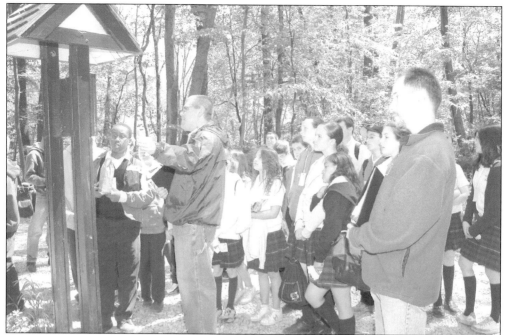

On Red Clay Valley History Days, the Wilmington and Western Railroad, in conjunction with the Friends of Brandywine Springs, conducted tours through the long-abandoned amusement park. In this photograph, Edward A. Lipka (left) describes the features and historical significance of the park to a group of young students while park docent Scott Palmer (right) listens attentively. (Courtesy of B. Michael Ciosek.)

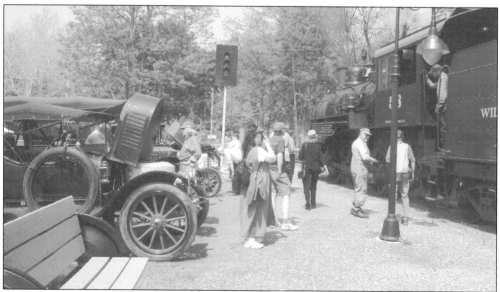

The Wilmington and Western Railroad hosted Celebrating Progress, a special event on May 21, 2005. The Marshall Steam Team provided five Stanley Steamer automobiles for display. Among the vehicles were a 1913 two-passenger, 20-horsepower roadster and a 1912 Mountain Wagon that seats 15 passengers. Short car rides were offered to the public as visitors waited for the departure of the 12:30 p.m. train to Mount Cuba. (Courtesy of B. Michael Ciosek.)

Linda and Brian R. Woodcock generously donated Locomotive No. 58 to HRCV, Inc., in 1997. Woodcock purchased Locomotive No. 58 from Malcolm Ottinger in 1973. (Courtesy of Brian R. Woodcock.)

On Sunday, May 23, 1998, Locomotive No. 58 was dedicated as the *Veterans Locomotive* during a ceremony at Greenbank station. Representatives of the armed forces, state and county elected officials, HRCV, Inc., members, and invited guests attend the event. At the request of Linda and Brian Woodcock, Locomotive No. 58 was dedicated to the memory of all Americans and allied veterans who served to preserve peace around the world. (Courtesy of Jose A. Vazquez.)

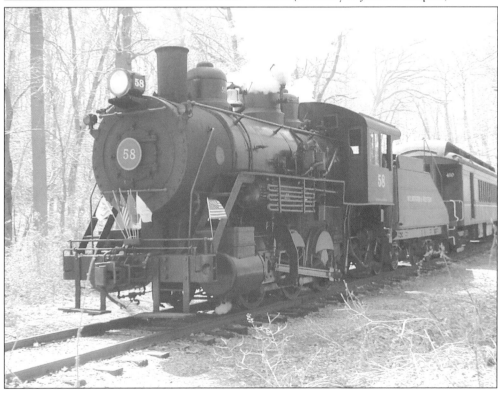

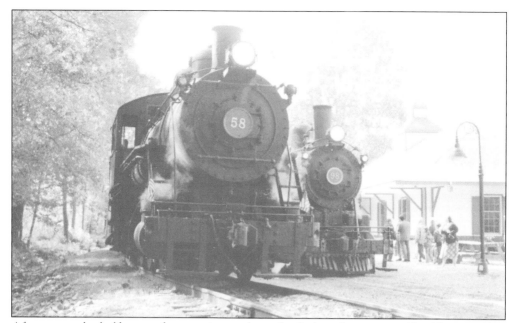

After two and a half years of restoration work on the firebox, Locomotive No. 98 returned to service in 2004. To celebrate the occasion, Locomotives Nos. 58 and 98 operated concurrently, pulling two different train consists. For the third and final trip of the day, the locomotives were coupled together and thrilled passengers as the first doubleheader in years left Greenbank station. (Courtesy of Andrew Gwiazda.)

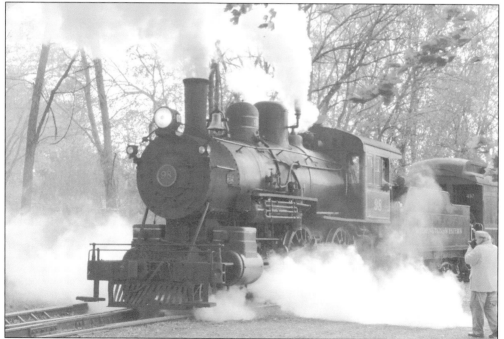

Steam Locomotive No. 98 vents its cylinders as it prepares to depart Greenbank station for the Halloween Express train. Photographers often line up to witness this amazing machine as it departs the station. (Courtesy of B. Michael Ciosek.)

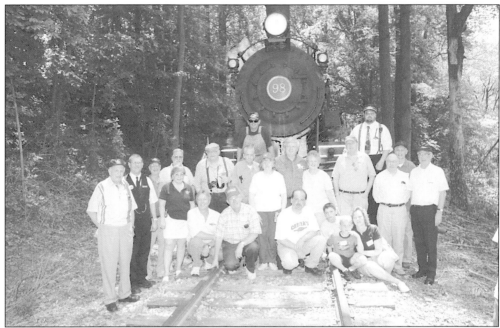

May 29, 2006, marked the 40th anniversary of HRCV, Inc. Early members who established the tourist railroad and their families were invited to join current directors and staff for the celebration. Attendees pose in front of Locomotive No. 98 before returning to Greenbank station for a brief ceremony. (Courtesy of B. Michael Ciosek.)

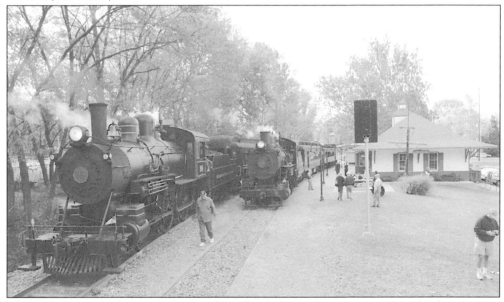

The Wilmington and Western Railroad was limited to a short section of track after the vast destruction caused by Tropical Storm Henri on September 16, 2003. Instead of excursion trains along the Red Clay Creek, passengers were offered the opportunity to experience two steam locomotives in operation during the Steam Meets Steam events. Locomotives Nos. 58 and 98 stand side by side during one of these special events at Greenbank station on October 16, 2005. (Courtesy of B. Michael Ciosek.)

Throughout the year, the Wilmington and Western Railroad offers special events dedicated entirely to young children. Trainman Donald Sober stands ready to assist four unidentified children dressed in costumes who visited the Wilmington and Western Railroad for a special Halloween Express train. (Courtesy of B. Michael Ciosek.)

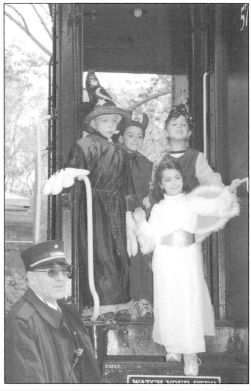

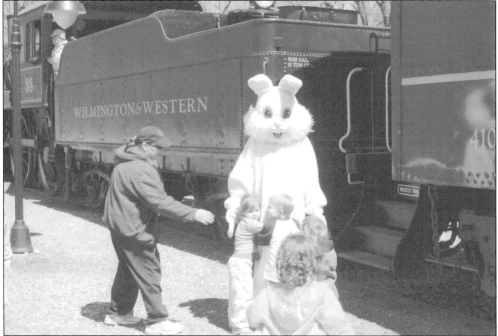

Every spring, to the delight of many youngsters, the Wilmington and Western Railroad features the Easter Bunny Express. This event marks the beginning of the regularly scheduled weekend excursions. (Courtesy of B. Michael Ciosek.)

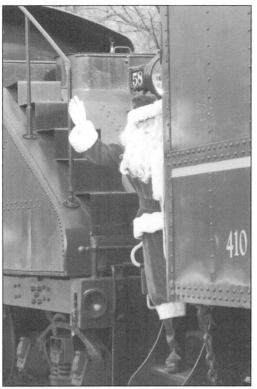

The most popular excursions offered by the Wilmington and Western Railroad are the Santa Claus Express trains. Every year, hundreds of moms and dads with their children gather at Greenbank station to ride the steam trains and celebrate the season with a visit to Santa. (Courtesy of B. Michael Ciosek.)

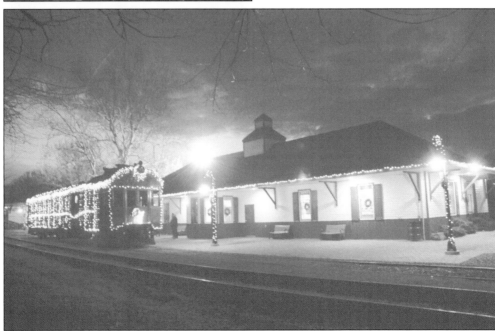

After Christmas and before the New Year, the Wilmington and Western Railroad schedules special evening rides along the Red Clay Creek. Volunteers decorate the station and the Doodlebug with festive lights and ornaments. Neighbors along the right-of-way provide a special sight by decorating their backyards. (Courtesy of B. Michael Ciosek.)

Four

STEAM LOCOMOTIVE
RESTORATION
1998–2004

From the time it was first incorporated, the crowning dream for HRCV, Inc., has been to operate a scenic tourist railroad with more than one operable steam locomotive for passenger service. To that end, two steam locomotives were acquired in the 1960s: Locomotive No. 92, built by the Canadian Locomotive Company in 1910, and ALCO Locomotive No. 98, built in 1909.

Locomotive No. 92 has the distinction of being the first steam locomotive used for the weekend excursion trains through the Red Clay Valley. This was the only steam locomotive in service until 1972, when Locomotive No. 98 began operations. Unfortunately, timing was not cooperative for the concurrent operation of both machines. Locomotive No. 92 was taken out of service one month before the repairs and restoration work on Locomotive No. 98 was completed. Locomotive No. 92 never returned to service. It is presently stored at the Wilmington and Western Railroad Marshallton Yard until restoration funds become available.

Locomotive No. 98 operated regularly until December 1997 when it also had to be removed from service due to major repairs needed in its firebox. Fortunately, Locomotive No. 58 had recently been acquired and could take over the duties left open by No. 98. Once again, the dream of two operating steam locomotives together was just beyond the Wilmington and Western's reach. Locomotive No. 58 became the primary steam motive power for the Wilmington and Western, as plans were underway to begin the firebox restorations needed by No. 98. No. 98 was dismantled for repairs in 2001. Two and a half years and $500,000 later, No. 98 was returned to service, and the long dream had been realized.

Although several steam locomotive restoration endeavors have been performed by the Wilmington and Western volunteers, this chapter will focus primarily on the firebox restorations of Locomotive No. 98. This project was made possible through generous financial support from New Castle County, county executive Thomas P. Gordon, and grants from many individuals, foundations, staff, and volunteers. Without the assistance and guidance provided by Historic Machinery Services, Inc., of Springdale, Alabama, the restoration of Locomotive No. 98 could never have been realized.

Locomotive No. 98 was taken out of service in December 1997 when it was determined that major repairs to its firebox would be needed. This photograph, taken in June 2001, shows the locomotive being dismantled outside the Wilmington and Western engine house. Major appliances, air pumps, jacketing, and the smoke-box door have been removed. Robert Yuill of Historic Machinery Services, Inc., (on the ground) and Steven L. Jensen (top), the Wilmington and Western chief mechanical officer, directed the restoration efforts. (Courtesy of Steven L. Jensen.)

In March 2002, the cab was removed, and the locomotive was placed inside the new back shop facility, where the boiler was lifted off the frame. This photograph shows the frame, main drivers, running gear, and cylinders stored outside on the Wilmington and Western main line. The ash pan was later removed and replaced by a new one. (Courtesy of Steven L. Jensen.)

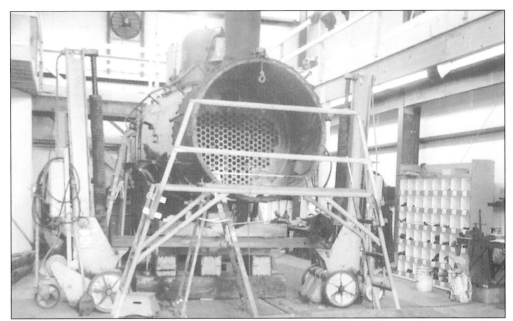

This photograph was taken inside the new shop building constructed in 2001 specifically to facilitate the restoration. Four 220-volt screw jacks were used to lift the boiler off the frame and place it on top of wood blocking. The dry pipe, which carries the steam to the cylinders, is seen on the floor in front of the boiler. It, along with the throttle, was removed and inspected. (Courtesy of Steven L. Jensen.)

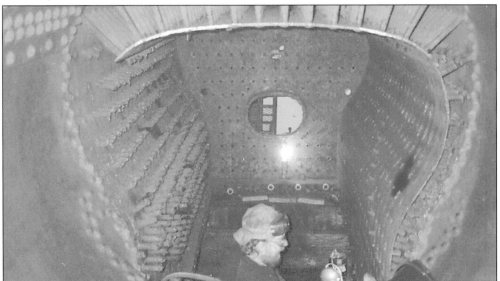

This photograph was taken from inside the boiler toward the rear end of the firebox. To the left, the cut-off stay bolts are still attached to the outside sheet. In the top center of the photograph, the flexible stay bolts are left intact and support the crown sheet. Only 25 percent of it was removed to gain access to the braces for inspection and replacement. To the right, the firebox side sheet is still in place, although the stay bolts are already cut. Stay bolts are required to keep the inside and outside sheets together when the boiler is subjected to required operating pressures. (Courtesy of Steven L. Jensen.)

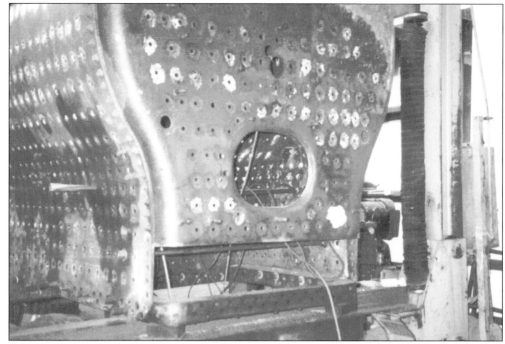

Contractors and staff, aided by volunteers, proceed to needle-chip the entire inside and outside of the boiler surface. The damaged section of the lower back head sheet was removed without damaging the mud ring. (Courtesy of Steven L. Jensen.)

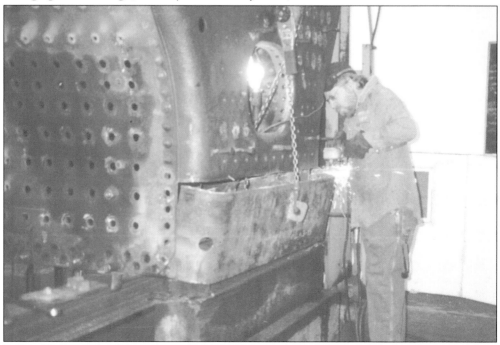

Robert Yuill grinds off excess material from the new lower back head sheet. The new section required several fitting trials. Once the new section proved to be a perfect fit, the damaged side sheet sections were removed. (Courtesy of Steven L. Jensen.)

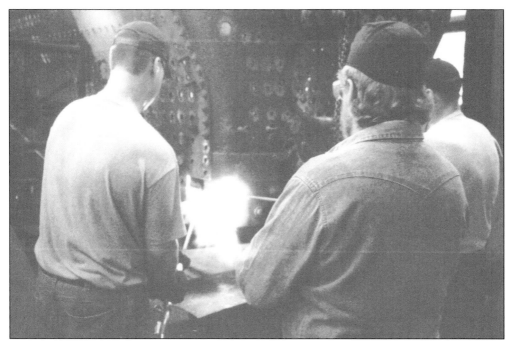

Contractors William Bryant (left) and Robert Yuill (center), along with Wilmington and Western Railroad volunteer Edward Hoffmeister (right), heat the new lower back head section to a high temperature in order to change the sheet into a malleable condition. (Courtesy of Steven L. Jensen.)

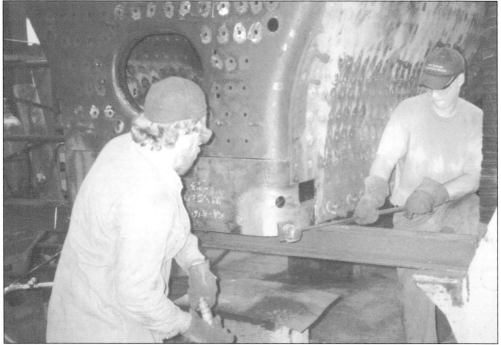

After the section is heated, Robert Yuill (left) and William Bryant hammer the edge in order to form a round corner. (Courtesy of Steven L. Jensen.)

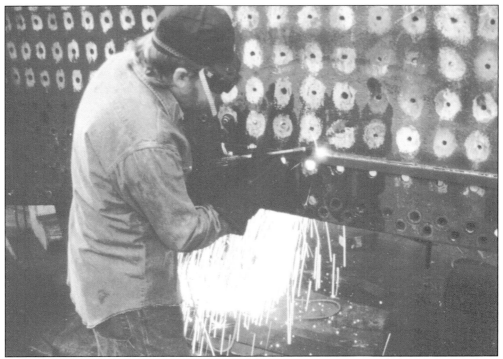

Robert Yuill cuts off the damaged sections of the left, right, and front firebox sheets. (Courtesy of Steven L. Jensen.)

The bottom of the firebox is secured on a heavy foundation ring commonly known as the mud ring. This photograph depicts the firebox with the front and lower side sheet sections removed. This restoration stage provides an excellent opportunity to see the mud ring. (Courtesy of Steven L. Jensen.)

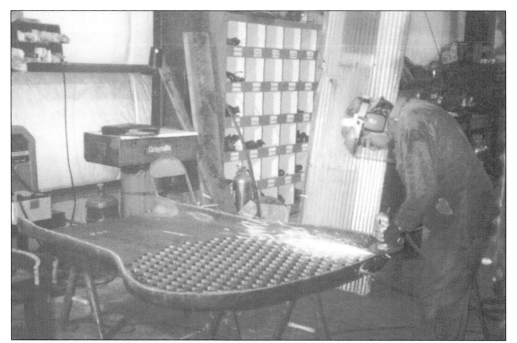

In this photograph, Robert Yuill grinds off excess material from the new rear flue sheet. A perfect fit is required before the sheet is welded into place. Braces are attached to strategically located stay bolts at the mid-lower section of the sheet in order to provide additional support. (Courtesy of Steven L. Jensen.)

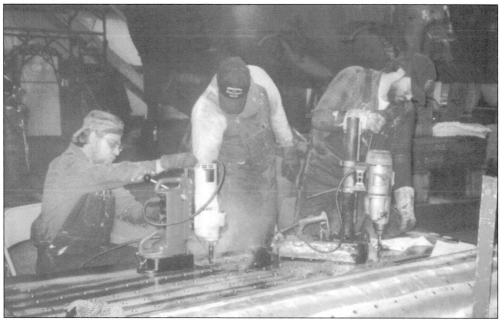

From left to right, Robert Yuill, William Bryant, and Steven Butler use magnetic drills to accurately drill stay-bolt holes on the firebox side sheets before installing them. Each hole was drilled, reamed, and tapped by hand. A total of 1,118 stay bolts were required for this restoration project. (Courtesy of Steven L. Jensen.)

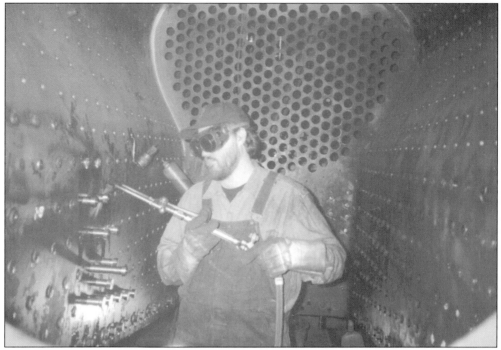

Working inside the boiler, Steven Butler cuts the excess material from the stay bolts. (Courtesy of Steven L. Jensen.)

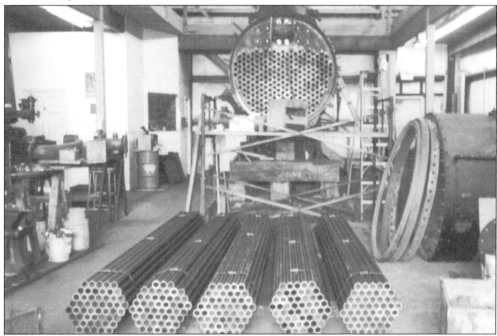

These flues were individually measured and cut to be used inside the boiler. A total of 258 flues fill the empty space below the dry pipe inside the boiler. The flues provide additional surface area for heat transfer. The flues also pass the combustion gasses from the firebox to the smoke box. (Courtesy of Steven L. Jensen.)

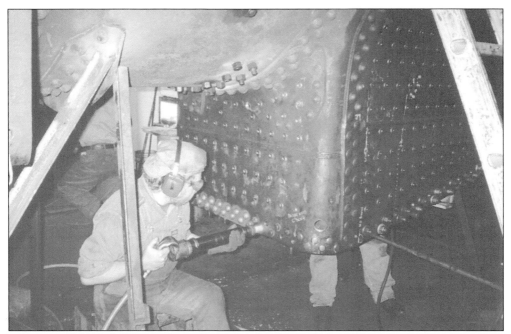

Robert Yuill drives hot rivets along the lower edge of the firebox. The rivets secure the outside and the inside firebox sheets to the mud ring. Riveting assures a tight seal between the sheets to prevent leaks from forming. (Courtesy of Jose A. Vazquez.)

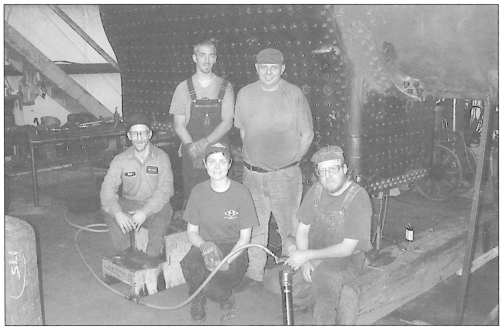

The extreme high temperature at which hot rivets are handled requires absolute trust and good communication skills from all team members. After all the hot rivets were driven on Locomotive No. 98, the group gathered for a photograph. From left to right are (first row) William Drotar, Gisela Vazquez, and Robert Yuill; (second row) Joshua Stone and Steven L. Jensen. (Courtesy of Jose A. Vazquez.)

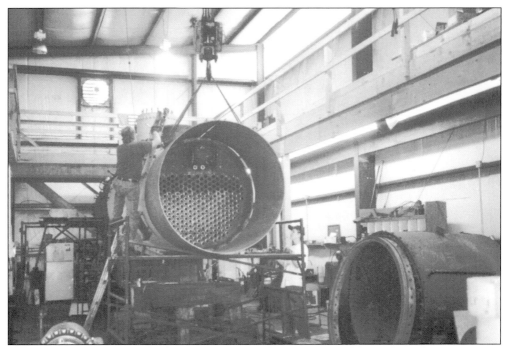

Robert Yuill (left) and Gisela Vazquez (right), assisted by crane operator Steven L. Jensen (not shown), check the alignment and fit of the new smoke box. Once the combustion gasses reach the smoke box, they are exhausted through the stack. (Courtesy of Steven L. Jensen.)

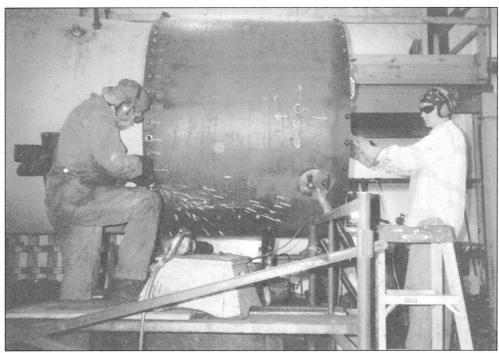

Robert Yuill (left) and Gisela Vazquez (right), aided by Joshua Stone (not shown), attach the inner smoke-box cover support ring to the smoke box with hot rivets. (Courtesy of Steven L. Jensen.)

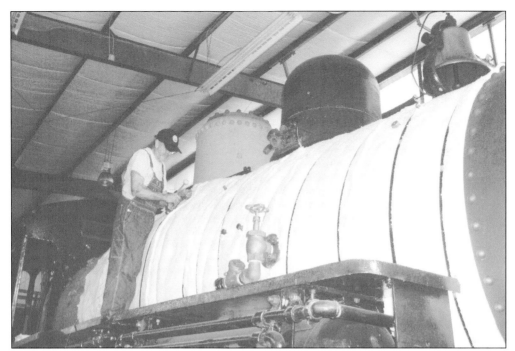

Wilmington and Western Railroad volunteer Donald Hooker secures the ceramic wool insulation. The entire boiler section is wrapped with insulation material to minimize heat loss. (Courtesy of Gisela Vazquez.)

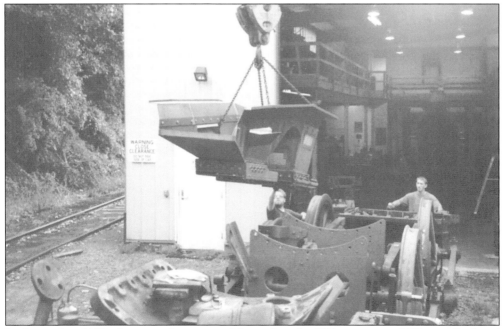

In September 2003, the new ash pan was delivered to the Wilmington and Western Railroad shop and lowered onto the frame. With the ash pan secured in place, all the remaining surfaces on the frame were cleaned and painted. The frame was now ready for the boiler shell. (Courtesy of Steven L. Jensen.)

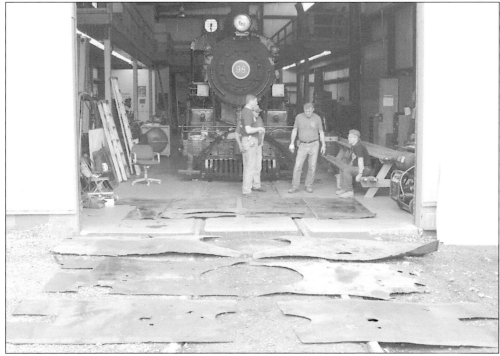

A group of local sheet metal workers volunteered their time and materials to make and install a new jacket for Locomotive No. 98. After the old sheets were spread out to be used as templates, the group gathers to discuss the plan to fabricate the new jacketing. (Courtesy of Gisela Vazquez.)

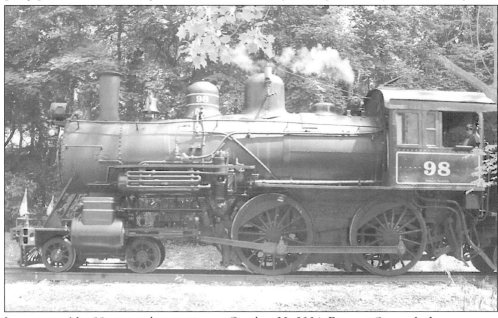

Locomotive No. 98 returned to service on October 30, 2004. Fireman Steven L. Jensen waves as the train approaches Faulkland Road (Route 34) on June 29, 2006. This day marked the 40th anniversary of operations of the Wilmington and Western Railroad as a historic steam railroad. (Courtesy of Gisela Vazquez.)

Five

Floods and Devastation
1999–2003

On September 16, 1999, remnants of Hurricane Floyd reached the Lower Delaware River Basin as a tropical storm that collided with a pre-existing frontal zone, causing rainfalls between 4 and 12 inches. The effect of this fast-moving storm was record-setting flood stages in all the creeks within the basin, including the Red Clay Creek. This volume of water rushing alongside the Wilmington and Western Railroad right-of-way resulted in the destruction of two wooden trestles and damage to 11 other bridges. Hundreds of washouts left the tracks suspended and twisted. After almost a year of arduous work by dedicated volunteers and contractors, the line was reopened. On November 25, 2000, excursion trains once again departed to Mount Cuba and Hockessin. However, the celebrations were short lived.

Four years later, on September 15, 2003, remnants of Tropical Storm Henri lingered over southern Chester County, Pennsylvania, causing the streams and rivers in northern New Castle County to reach flood-stage levels. At Wooddale, U.S. Geological data indicated that the Red Clay Creek crested at a new record of 17.61 feet. Because the Wilmington and Western tracks run parallel to the creek, the force of the raging waters destroyed six bridges, damaged one, and once again caused severe washouts along eight miles of track. HRCV, Inc., rebuilt the damage caused by the storm, employing the most modern engineering methods and materials available while maintaining the historical character of the railroad. After almost four years of fund-raising, designs, engineering, permits, and construction, the line was completely reopened on June 30, 2007.

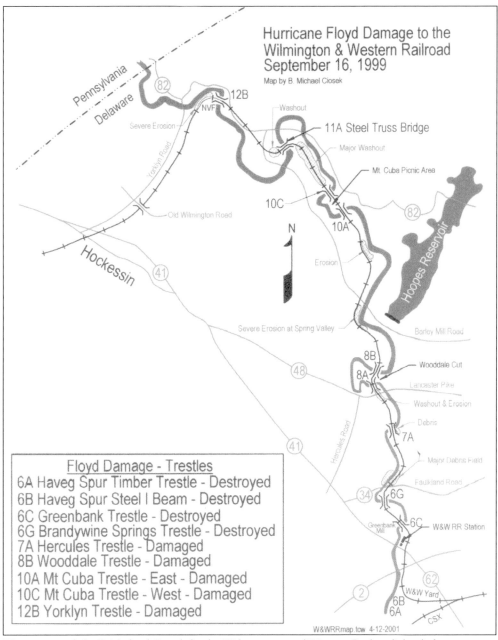

Hurricane Floyd Damage to the
Wilmington & Western Railroad
September 16, 1999

Map by B. Michael Ciosek

Pennsylvania

Delaware

82

12B

NVF

Washout

Severe Erosion

11A Steel Truss Bridge

Yorklyn Road

Major Washout

Mt. Cuba Picnic Area

10C

N

10A

82

Hoopes Reservoir

Old Wilmington Road

Hockessin

41

Erosion

Severe Erosion at Spring Valley

Barley Mill Road

8B

Wooddale Cut

48

8A

Lancaster Pike

Washout & Erosion

Debris

Hercules Road

7A

Major Debris Field

41

Faulkland Road

34

6G

Greenbank Mill

6C

W&W RR Station

Floyd Damage - Trestles
6A Haveg Spur Timber Trestle - Destroyed
6B Haveg Spur Steel I Beam - Destroyed
6C Greenbank Trestle - Destroyed
6G Brandywine Springs Trestle - Destroyed
7A Hercules Trestle - Damaged
8B Wooddale Trestle - Damaged
10A Mt Cuba Trestle - East - Damaged
10C Mt Cuba Trestle - West - Damaged
12B Yorklyn Trestle - Damaged

62

2

W&W Yard

6B
6A

CSX

W&WRRmap.tcw 4-12-2001

This map, made by B. Michael Ciosek for the Wilmington and Western Railroad's book documenting the damage from Hurricane Floyd, shows the length of the in-service track and the damage caused by Hurricane Floyd on September 16, 1999. The Wilmington and Western bridges begin with 6A at the bottom right of the map and continue upwards following the Red Clay Creek. The last bridge is the S Trestle, 12B, at the top-center. From 12B, the tracks leave the creek valley and climb steadily toward the town of Hockessin. (Courtesy of HRCV, Inc.)

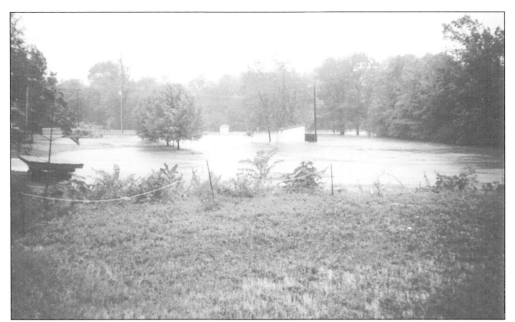

The Wilmington and Western Railroad's Greenbank station parking lot off Delaware Route 41 North was completely filled with water the afternoon of September 16, 1999. The angled-roof building (off center to the right) is a men's and ladies' restroom. The small building in the center of the photograph is an original watchman's shanty that had been donated to Wilmington and Western by the B&O. (Courtesy of HRCV, Inc.)

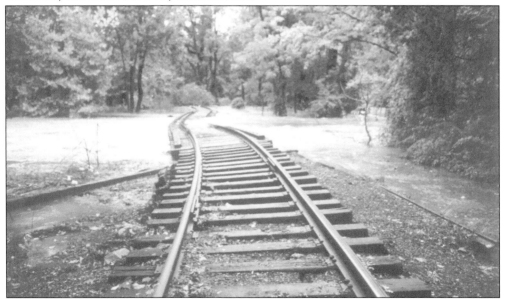

The Greenbank Trestle, Bridge 6C, crosses the Red Clay Creek at Mile Post 1.5 on the Wilmington and Western Railroad tracks. This picture shows the bridge severely compromised late in the afternoon of September 16, 1999. Later in the evening, the location of this photograph was completely covered by floodwaters. As daylight returned on the morning of September 17, it was clear to see that Bridge 6C had succumbed to the pressure of the powerful water and had washed away. (Courtesy of David S. Ludlow.)

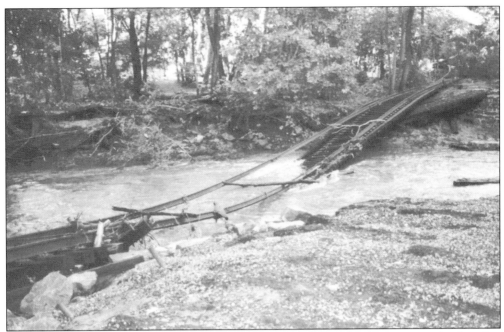

This is the view of Bridge 6C, the first bridge westbound of Greenbank station, on the day after Hurricane Floyd. The supporting beams were completely ripped off the piers, and the tracks were pulled 50 feet downstream. Only the rails remained connected to tracks on either side of the Red Clay Creek. (Courtesy of David S. Ludlow.)

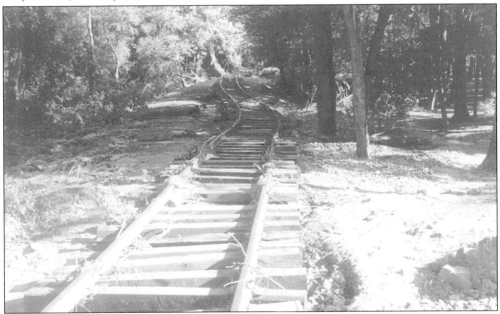

Sights like these were common along eight miles of track after Hurricane Floyd. Within a few days of the flood, volunteers began to stabilize the track in the damaged areas. Shown here is one of the largest washouts, which occurred at Brandywine Springs Park east of Bridge 6G, Mile Post 1.75. Over 250 tons of fill—quarry products of mixed-size stone, rock, and two-inch ballast—were needed to repair this area. (Courtesy of HRCV, Inc.)

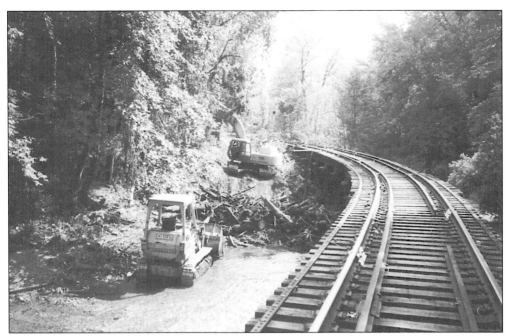

Bridge 12B, also known as the S Trestle, was clogged with vegetative debris along its entire upstream side. Heavy equipment was used to clear out the obstructions. Bents three and four of this bridge were pushed out of position, but other than that, damage to 12B was minimal. (Courtesy of David S. Ludlow.)

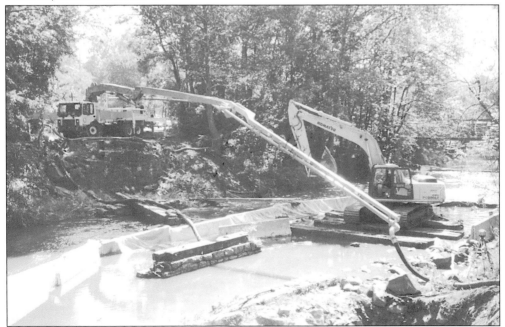

This photograph shows the mobile concrete pump preparing to fill the west abutment of Bridge 6C. This pump could deliver concrete from the east bank of the Red Clay Creek to the west abutment. Cofferdams (center) were used to divert stream flow and permit construction of the middle piers. (Courtesy of HRCV, Inc.)

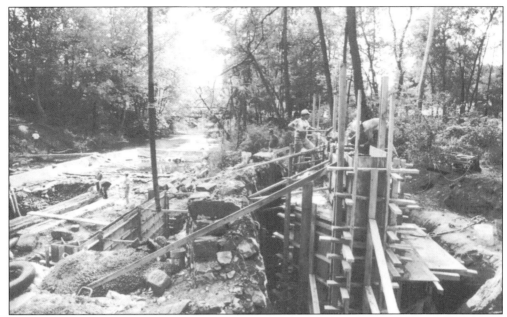

The west abutment for Bridge 6C was formed using wood and steel. Inside these forms are the reinforcing bars that provide additional strength to the concrete. The original granite stone face was left in place as a veneer to preserve the historical character of what once supported the bridge. While contractors repaired the damaged and destroyed bridges, Wilmington and Western Railroad track volunteers filled the major washouts and repaired damaged track at Brandywine Springs, Wooddale, Spring Valley, Mount Cuba, Ashland, and Yorklyn. More than 1,000 tons of rock and stone fill were used to repair washouts along the rail line. (Courtesy of HRCV, Inc.)

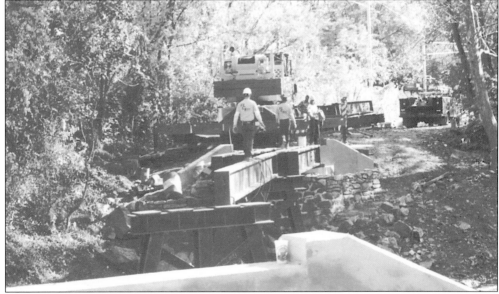

The new steel trestles were constructed with half the number of bents (support legs) that were found on the previous wooden trestles. This design change provided more free space for floating debris to flow through, thus avoiding the trash accumulating against the bridge. Ironworkers are pictured during the process of installing 16 steel stringers on Bridge 6C. (Courtesy of David S. Ludlow.)

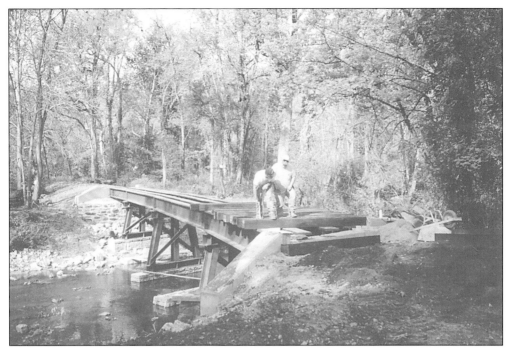

In this photograph, 8-inch-by-8-inch-by-10-foot bridge deck timbers are placed on the stringers of Bridge 6C at Greenbank. Deck timbers serve the same purpose as crossties do. They are, however, usually longer, wider, and taller. (Courtesy of HRCV, Inc.)

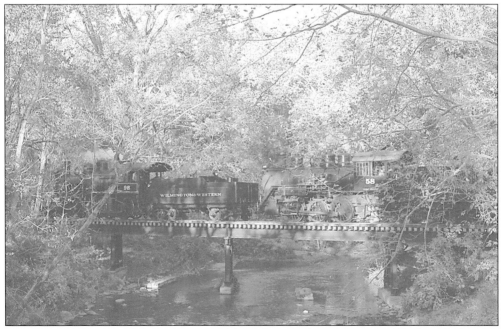

Locomotives Nos. 98 and 58 travel as a doubleheader over the reconstructed Bridge 6C. On May 19, 2001, this bridge was renamed Ludlow Bridge in honor of Wilmington and Western Railroad executive director David S. Ludlow for his diligence and hard work in rebuilding the railroad from the damage caused by Hurricane Floyd. (Courtesy of B. Michael Ciosek.)

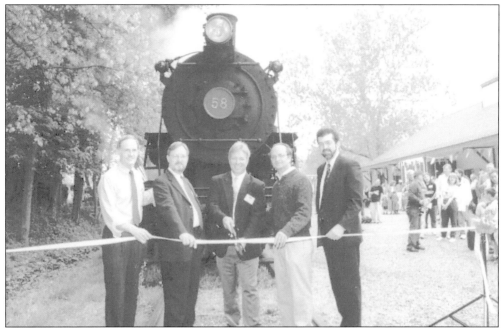

On May 19, 2001, HRCV, Inc., celebrated the reopening of the Landenberg Branch for passenger service. The festivities were held at Greenbank station. Preparing to cut the ceremonial ribbon are, from left to right, U.S. Senator Thomas Carper; HRCV, Inc., president Ronald Bailey; Wilmington and Western Railroad executive director David S. Ludlow; New Castle County executive Thomas Gordon; and John Dorsey, the representative for U.S. Senator Joseph R. Biden. (Courtesy of HRCV, Inc.)

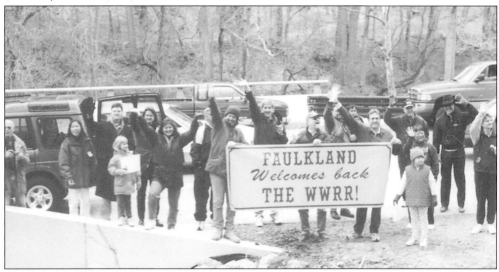

Neighbors of the Faulkland Road (Route 34) community gathered at the grade crossing on November 25, 2000, to welcome the first Wilmington and Western Railroad excursion train running westbound from Greenbank station to Mount Cuba. This was the first revenue train over the newly repaired track and bridges. Artist Larry S. Anderson, famous for his beautiful paintings of the Wilmington area, including Wilmington and Western Railroad scenes, and David Cooper organized this event. (Courtesy of B. Michael Ciosek.)

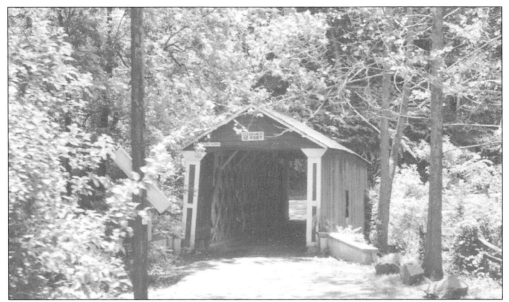

One of the most scenic locations along the Wilmington and Western Railroad right-of-way was the Wooddale Covered Bridge. This bridge was one of three remaining covered bridges in New Castle County. The town truss–type bridge was originally built in 1870 with a span of 60 feet above the Red Clay Creek and was 12 feet wide. It stood near Foxhill Lane just west of Rolling Mill Road and north of Route 48. Bridges of this type were roofed and covered to protect the superstructure from rot. They are known for their rigidity and capability to support large loads. (Courtesy of HRCV, Inc.)

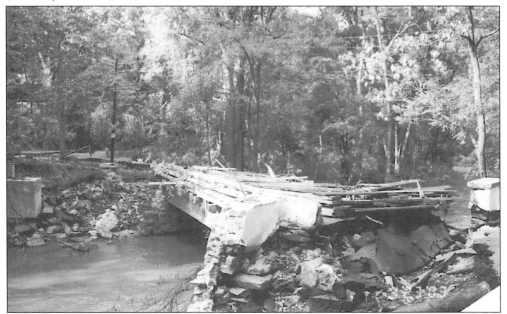

The Wooddale Covered Bridge was completely destroyed on September 16, 2003, as Tropical Storm Henri stalled over Chester County, Pennsylvania. The remains of the bridge were completely removed, and construction of a new covered bridge will be completed in 2008. (Courtesy of David S. Ludlow.)

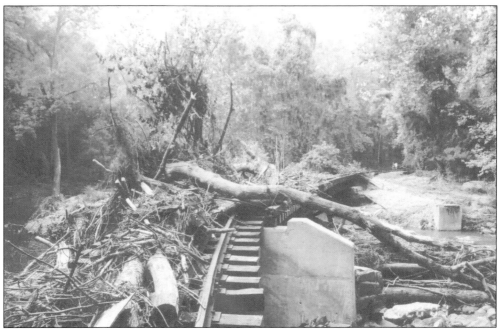

Bridge 6G spans the Red Clay Creek at Brandywine Springs. This photograph was taken the day after Tropical Storm Henri passed over the area. The bridge was not destroyed during the flood, but one of the support piers settled, causing the damaged structure to sag at the west end. (Courtesy of David S. Ludlow.)

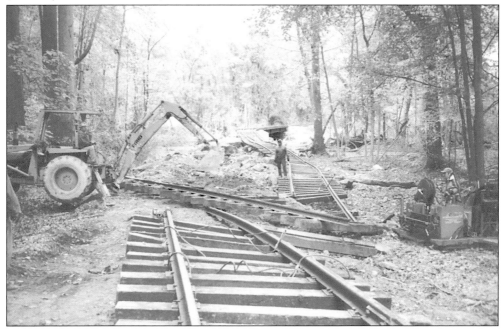

This photograph was taken on October 23, 2003, east of the approach to Bridge 6G at Brandywine Springs, Mile Post 1.75. Weekday track workers begin repairs of this section of track. From left to right, executive director David S. Ludlow operates the backhoe while Leonard Beck and Jeffrey Yatkowski wait at a safe distance. (Courtesy of HRCV, Inc.)

Wilmington and Western Railroad chief mechanical officer Steven L. Jensen unloads riprap (large boulders) at the east approach of Bridge 6G. Riprap is a good stabilizer of soils because it lessens the velocity of the rushing waters and limits erosion. During Tropical Storm Henri, this location was completely washed away to a depth of more that 10 feet below track level. (Courtesy of Gisela Vazquez.)

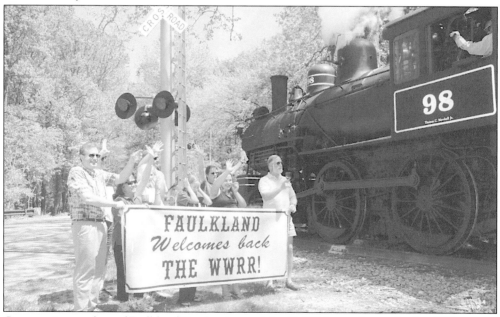

Community members of Faulkland Road gather on May 17, 2006, to welcome the first Wilmington and Western Railroad excursion train west of Brandywine Springs in almost three years. HRCV, Inc., director Larry Anderson holds the left corner of the welcoming banner while neighbor John Ingram holds the right corner. (Courtesy of HRCV, Inc.)

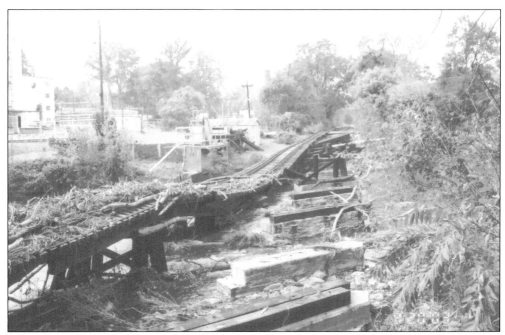

The flooding from Tropical Storm Henri was much worse than that of Hurricane Floyd. Bridge 7A, a 195-foot span at Mile Post 2.70 behind the Hercules Research Center, was destroyed by the floodwaters. Debris was deposited on top of the bridge, the stringers were ripped out of place, and the entire decking was moved down stream from the bents. (Courtesy of David S. Ludlow.)

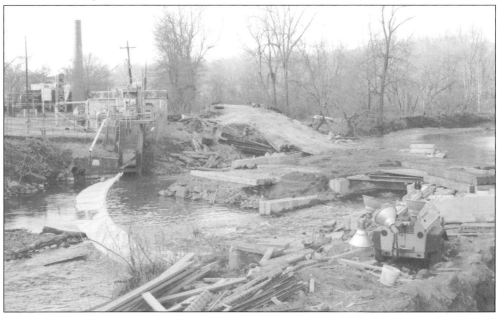

Bridge 7A was the second of seven bridges to be reconstructed following the award of a contract. Before construction of the bridge began, an access road was built down the existing right-of-way with intermediate temporary bridges over the creek to allow access to the far abutment. The large platform in the center of the photograph is the stage for the drilling machine, which drilled shafts into the bedrock to support the piers. (Courtesy of David S. Ludlow.)

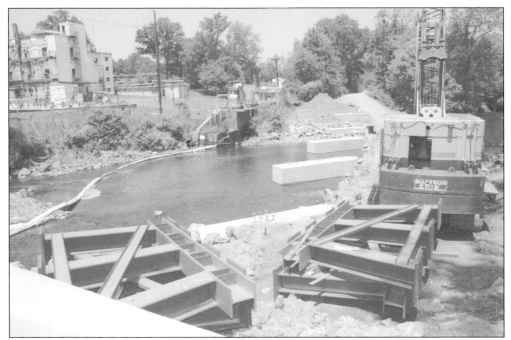

At the time of this photograph, Bridge 7A was almost 50 percent complete. The new piers have been constructed with anchor bolts cast into the poured concrete. The steel structures in the foreground are the bents (support legs), which are bolted to the piers and support the stringers. (Courtesy of B. Michael Ciosek.)

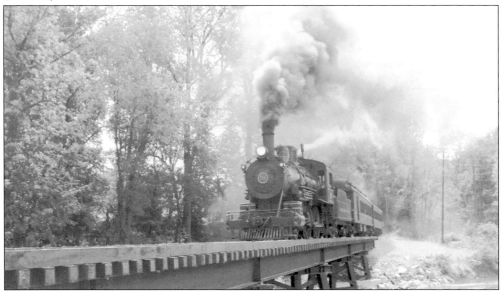

On September 3, 2006, Wilmington and Western Railroad Locomotive No. 98 leads the 12:30 p.m. Valley Local excursion train over the newly rebuilt Bridge 7A. With the reopening of this bridge, 1.5 miles of track were added, allowing trains to travel close to Lancaster Pike, Delaware Route 48. This new steel bridge is 195 feet long and is supported by five bents instead of the nine that supported the old wooden trestle. The depth of the rock sockets at the piers varies between 6.5 and 7.5 feet. The cost to rebuild this bridge was $1,705,807. (Courtesy of B. Michael Ciosek.)

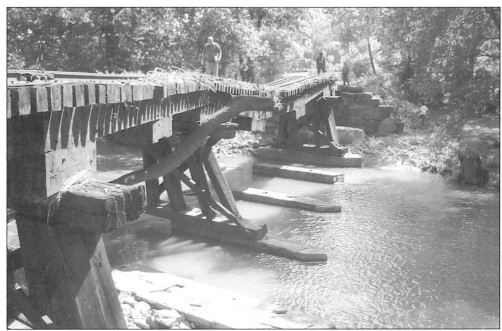

On September 16, 2003, Wilmington and Western volunteer Clayton Foster walks over Bridge 8A at Mile Post 3.3 west of Lancaster Pike to assess the damage from Tropical Storm Henri. The damage to this bridge was remarkably less than other spans, probably due to the wide-open flood plain, which allows the water to somewhat dissipate its energy. (Courtesy of David S. Ludlow.)

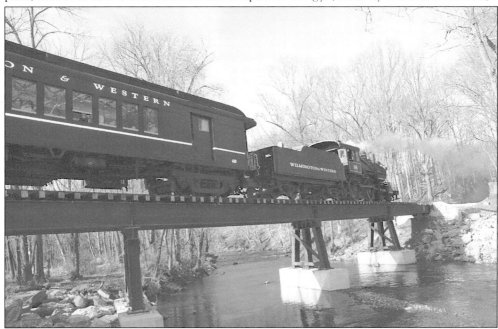

Locomotive No. 98 and Coach No. 410 cross the newly rebuilt Bridge 8A. This new steel bridge is 164 feet long and is supported by three bents instead of the seven that supported the old wooden trestle. The depth of rock sockets at piers varies between 5 and 9 feet. The cost of rebuilding this bridge reached $1,369,025. (Courtesy of B. Michael Ciosek.)

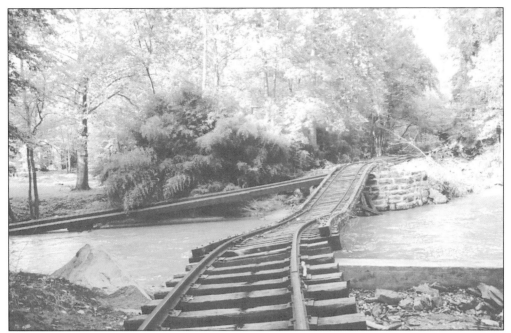

This photograph of Bridge 8B at Mile Post 3.4 west of the Wooddale Rock Cut dates to September 16, 2003. On the left side of the photograph, the bridge stringers lay strewn on the far bank of the creek. Without the stringers and the bents, the deck hangs suspended like a ribbon above the receding creek. (Courtesy of David S. Ludlow.)

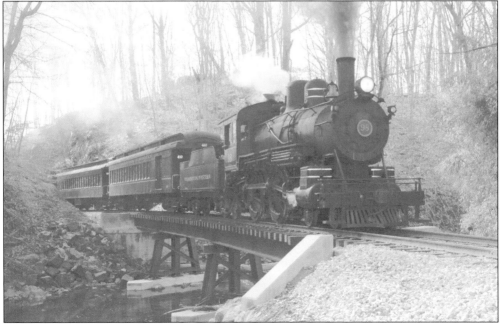

Locomotive No. 98 crosses over the new Bridge 8B at Wooddale. The date is November 25, 2006. This bridge is 100.5 feet long and has two bents instead of the four that supported the old wooden trestle. The depth of the drilled rock sockets at the piers varies between 8.5 and 11 feet. The cost of rebuilding this bridge reached $949,920. (Courtesy of B. Michael Ciosek.)

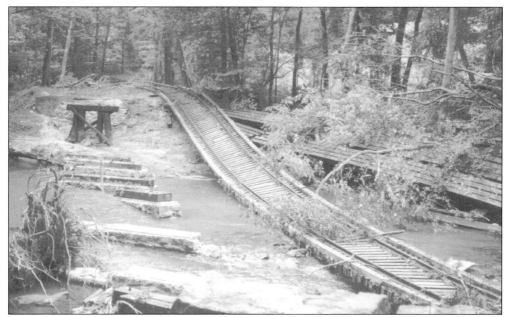

This photograph shows the wreckage of Bridge 10A at Mile Post 5.2 on September 16, 2003. The old wooden stringers are on the far right of the picture against the Red Clay Creek bank. The bridge decking lays almost intact with the deck and rail connected across the creek. The piers and one bent remain in place. Note that the one pier in the center of the photograph is skewed downstream. This is the bridge that leads into Mount Cuba Picnic Grove. (Courtesy of David S. Ludlow.)

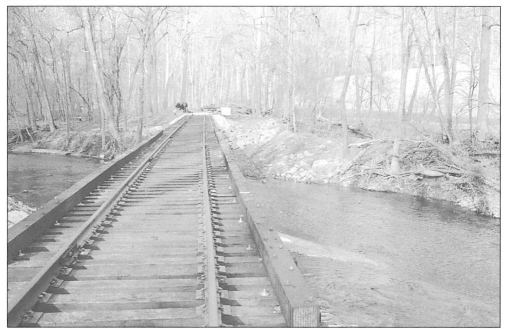

The new, steel Bridge 10A is 197 feet long and is supported by four bents instead of the nine that that supported the old wooden trestle. The depth of rock sockets at piers varies between 7 and 9 feet. The cost of rebuilding this bridge reached $1,020,100. (Courtesy of David S. Ludlow.)

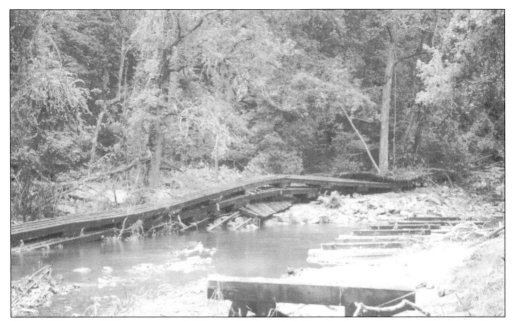

The well-known Wilmington and Western Railroad S Trestle, located south of Yorklyn along Delaware Route 82, was completely destroyed on September 15, 2003. This picture was taken the following day; the stringers snake across on the opposite bank of the Red Clay Creek, and the ties and rails were dispersed downstream for miles. Only one bent and the stone piers remained in place. (Courtesy of David S. Ludlow.)

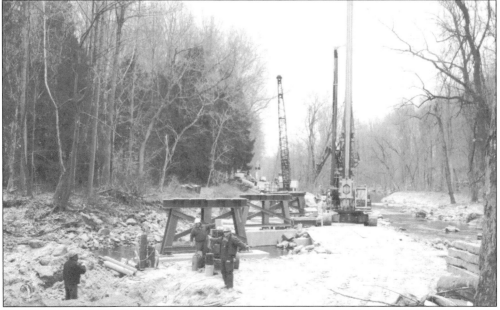

On February 1, 2007 the last hole for the last pier was drilled at Bridge 12B. There was still much to do before the bridge could be returned to service, but this marked the end of the slow, monotonous, noisy, task of drilling into solid rock. By May 2007, this bridge was reopened, and the rebuilding of the Wilmington and Western Railroad had been completed. (Courtesy of David S. Ludlow.)

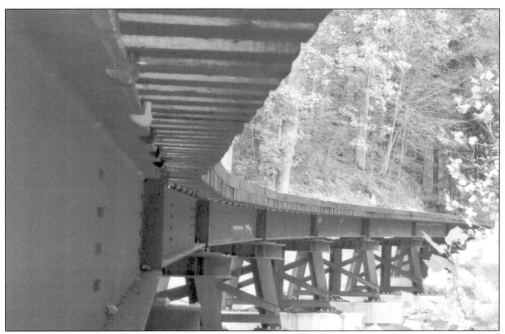

The new Bridge 12B is 430 feet long and is supported by eight bents. The depth of the rock sockets at the piers varies between 6 and 14 feet. The cost to rebuild Bridge 12B was $1,782,325. The new steel bridge retained the inverted curve, thus preserving the S character of the original wooden trestle. (Courtesy of Gisela Vazquez.)

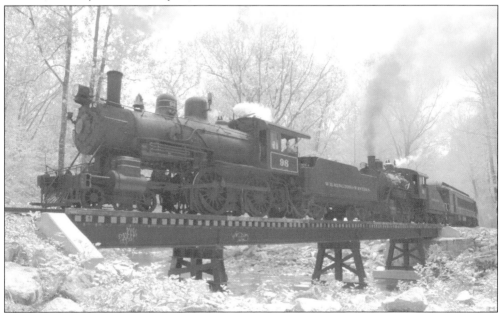

Locomotives Nos. 98 and 58 lead a doubleheaded consist on May 6, 2007, over the new Bridge 6G at Brandywine Springs. In recognition of their remarkable perseverance in the restoration of the Wilmington and Western Railroad, HRCV, Inc., was awarded the 2007 Preservation Delaware Award in the category of Preservation/Restoration of a Local Historic Resource. (Courtesy of B. Michael Ciosek.)

Six

REOPENING OF THE LINE
2007

The devastation caused by Topical Storm Henri on September 16, 2003, surpassed any damage the Wilmington and Western Railroad had ever experienced before. For almost four years, the most frequent sight along the 10.2 miles of track was construction workers and equipment. For almost two and a half years, train rides were limited to less than two miles of track, forcing HRCV, Inc., members and volunteers to create alternatives that would meet visitors' expectations.

At a slow and steady pace, the bridges and track sections were rebuilt and subsequently reopened. The scenic excursions began to extend along the Red Clay Creek, and passenger trains began to arrive at Mount Cuba Picnic Grove in May 2007. One month later, the entire length of the Landenberg Branch was finally repaired and ready to be reopened. The weeklong reopening celebrations began on June 24, 2007, with the long-absent Wild West Robbery trains and concluded when a sold-out passenger train pulled by Locomotive No. 98 and carrying a big "We're Back" banner arrived in downtown Hockessin. The hour-long, grand reopening celebration included live bluegrass music, speeches from dignitaries, and the traditional driving of a golden spike. The community support was overwhelming.

The Wilmington and Western Railroad survived this scale of devastation thanks to the financial assistance of the Federal Emergency Management Agency (FEMA), the State of Delaware, New Castle County, private foundations, and individuals. The continuous and loyal support of the community, the commitment of HRCV, Inc., officers and directors, and the dedication and perseverance of staff and volunteers made the rebuild a reality. Their common ambition to preserve Delaware's only historic steam tourist railroad made certain that the Wilmington and Western Railroad would be enjoyed for many future generations.

At the HRCV, Inc., annual meeting on March 10, 2007, Wilmington and Western Railroad staff members received a special recognition for their outstanding performance during the reconstruction period following the destruction by Tropical Storm Henri. Assistant trainmaster Jeffrey Hammaker presented awards contributed by Wilmington and Western Railroad volunteers. In this photograph are, from left to right, chief mechanical officer Steven L. Jensen, assistant trainmaster Jeffrey Hammaker, executive director David S. Ludlow, executive assistant Carole R. Wells, and shop mechanic Henryk Twardowski. (Courtesy of B. Michael Ciosek.)

From left to right, William Scheper, Henryk Twardowski, David S. Ludlow, and Steven L. Jensen stand on the rear platform of diesel Locomotive No. 114 on June 14, 2007. This was the first day that the Wilmington and Western Railroad arrived in downtown Hockessin after the 2003 destruction caused by Tropical Storm Henri. The crew, led by Ludlow, cleared the track of brush and other obstructions that had accumulated during the previous four years. (Courtesy of Gisela Vazquez.)

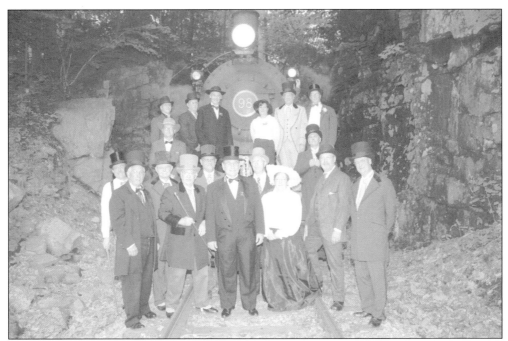

In a photograph re-creation, HRCV, Inc., officers and directors and Wilmington and Western Railroad staff members pose in front of Locomotive No. 98 at the Mount Cuba Rock Cut at Mile Post 5.6 on June 27, 2007. The stage and appropriate dress for this photograph is identical to one taken in 1875. From left to right are (first row) Frank C. Mayer, Paul W. Harris, Horace A. Wahl Jr., Carole R. Wells, Ronald T. Bailey, and John M. Iwasyk; (second row) Larry S. Anderson, Robert B. Taylor, Edward A. Lipka, and Michael T. Downs; (third row) Dennis Barba and John W. Hentkowski; (fourth row) Scott A. Tollefson, Ralph Inman, Peter O. Lane, Sue Knisely, Robert H. Spencer, and David S. Ludlow. (Courtesy of B. Michael Ciosek.)

The Wilmington and Western Railroad crewmembers who volunteered for the June 27, 2007, reopening celebration also took the opportunity to pose in front of Locomotive No. 98. They are, from left to right, (first row) Steven L. Jensen, Harold Woodin, Peter Dirga, and John D. Wentzell; (second row) A. K. Kissell and Donald Young; (third row) Evan Stauffer, Mark Blackwell, Andrew Gwiazda, and Steven M. Jensen. (Courtesy of B. Michael Ciosek.)

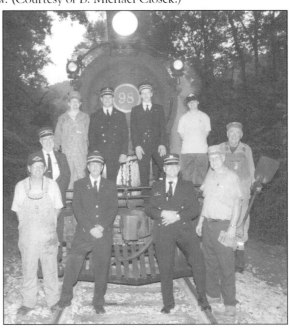

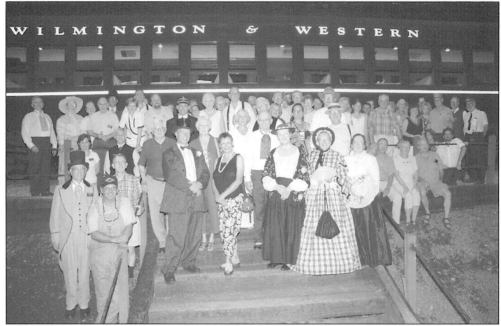

On June 27, 2007, HRCV, Inc., members and guests pose at the steps that lead to the railroad's picnic grove at Mount Cuba. The evening excursion included dinner on board the train, staged photographs, and a champagne toast to commemorate the reopening of the Wilmington and Western Railroad. (Courtesy of B. Michael Ciosek.)

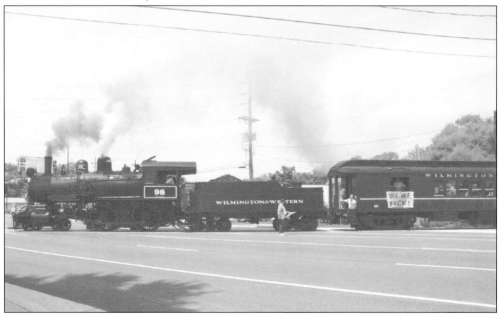

Locomotive No. 98 and Combine Coach No. 410 cross over Delaware Route 41 North as it arrives in Hockessin on June 30, 2007. The banner displayed from Coach No. 410 announces "We're Back." Numerous well-wishers lined the right-of-way from Greenbank to Hockessin and joined in the momentous occasion. Wilmington and Western Railroad executive director David S. Ludlow, waving proudly, rides the front steps of Coach No. 410. (Courtesy of B. Michael Ciosek.)

Wilmington and Western Railroad executive director David S. Ludlow proudly displays the golden spike to the public moments before driving it into a crosstie in downtown Hockessin. Reminiscent of the completion of the Transcontinental Railroad, this act symbolized the official reopening of the Wilmington and Western Railroad for passenger service. The spike was later removed for public display. (Courtesy of B. Michael Ciosek.)

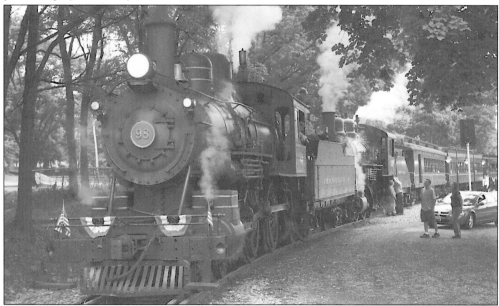

On July 4, 2007, Locomotives Nos. 98 and 58 joined forces and traveled from Greenbank station to Hockessin as a festive doubleheaded steam train. The sold-out train consisted of enclosed Erie-Lackawanna coaches, the recently restored parlor car, an open-air car, one caboose, and diesel Locomotive No. 114. This event was the last one planned as part of the weeklong, grand reopening celebrations of the Landenberg Branch. It also heralded the beginning of a new era for the Wilmington and Western Railroad. (Courtesy of Edward J. Feathers.)

DISCOVER THOUSANDS OF LOCAL HISTORY BOOKS
FEATURING MILLIONS OF VINTAGE IMAGES

Arcadia Publishing, the leading local history publisher in the United States, is committed to making history accessible and meaningful through publishing books that celebrate and preserve the heritage of America's people and places.

Find more books like this at
www.arcadiapublishing.com

Search for your hometown history, your old stomping grounds, and even your favorite sports team.

Consistent with our mission to preserve history on a local level, this book was printed in South Carolina on American-made paper and manufactured entirely in the United States. Products carrying the accredited Forest Stewardship Council (FSC) label are printed on 100 percent FSC-certified paper.

MADE IN THE USA